Modern Art: A Very Short Introduction

VERY SHORT INTRODUCTIONS are for anyone wanting a stimulating and accessible way in to a new subject. They are written by experts, and have been published in more than 25 languages worldwide.

The series began in 1995, and now represents a wide variety of topics in history, philosophy, religion, science, and the humanities. Over the next few years it will grow to a library of around 200 volumes – a Very Short Introduction to everything from ancient Egypt and Indian philosophy to conceptual art and cosmology.

Very Short Introductions available now:

For more information visit our web site

www.oup.co.uk/vsi/

David Cottington

MODERN ART

A Very Short Introduction

OXFORD
UNIVERSITY PRESS

OXFORD
UNIVERSITY PRESS

Great Clarendon Street, Oxford OX2 6DP

Oxford University Press is a department of the University of Oxford.
It furthers the University's objective of excellence in research, scholarship,
and education by publishing worldwide in

Oxford New York

Auckland Cape Town Dar es Salaam Hong Kong Karachi Kuala Lumpur
Madrid Melbourne Mexico City Nairobi New Delhi Shanghai Taipei Toronto

With offices in

Argentina Austria Brazil Chile Czech Republic France Greece
Guatemala Hungary Italy Japan South Korea Poland Portugal
Singapore Switzerland Thailand Turkey Ukraine Vietnam

Oxford is a registered trade mark of Oxford University Press
in the UK and in certain other countries

Published in the United States
by Oxford University Press Inc., New York

British Library Cataloguing in Publication Data

Data available

Library of Congress Cataloging in Publication Data

Cottington, David.
Modern art: a very short introduction/David Cottington.
p. cm.—(Very short introductions)
1. Art, Modern—20th century. 2. Art, Modern—19th century.
I. Title II. Series
N6490.C68 2005 709'.04—dc22 2004027127

ISBN 978-0-19-280364-1

7 9 10 8 6

Typeset by RefineCatch Ltd, Bungay, Suffolk
Printed in Great Britain by
Ashford Colour Press Ltd., Gosport, Hampshire

Contents

List of illustrations

Chapter openings

The publisher and the author apologize for any errors or omissions in the above list. If contacted they will be pleased to rectify these at the earliest opportunity.

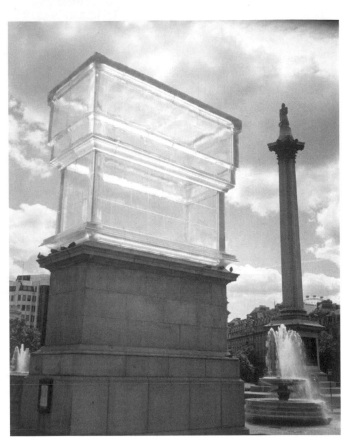

I. Rachel Whiteread, *Monument* (2001).

Introduction: modern art – monument or mockery?

When Rachel Whiteread's sculpture *Monument* (Plate I) was installed on the empty fourth plinth in London's Trafalgar Square on 4 June 2001, the response reported in, and offered by, British national newspapers the next day was entirely predictable. Like the two previous temporary incumbents of this site (works by contemporary artists Mark Wallinger and Bill Woodrow), *Monument* – a clear resin cast of the plinth itself, inverted and set on top of it – was immediately pilloried: condemned as 'banal', 'gimmicky', and 'meaningless' by the *Daily Mail*, and disparagingly likened to a fishtank and a bathroom cubicle by members of the public, according to the *Times*. Some newspapers also quoted the supportive – but also vague and defensive – comments of members of the cultural establishment. The then Culture Secretary Chris Smith, Director of Tate Modern Lars Nittve, and the Tate's Director of Programmes Sandy Nairne praised *Monument* variously as 'beautiful', 'intelligent', and 'dazzling' in its simplicity and conceptual clarity. They made no effort, though, to answer the condemnations. Nor did they point to the meanings about monuments and their purposes that Whiteread's piece had provocatively suggested by echoing and inverting the plinth itself.

Such a mismatch between the public's language of ridicule and establishment apologetics has, of course, been characteristic of the relation between modern art and its popular audience for longer

now than anyone can remember. Recent instances such as Tracey Emin's *My Bed* and Gavin Turk's bin bags merely reprise the 'scandals' of previous generations, of which the fuss over the Tate's purchase in 1976 of Carl André's stack of firebricks entitled *Equivalent VIII* (1966) – or, to go further back, Marcel Duchamp's submission of a urinal to a New York sculpture exhibition in 1918 – are perhaps the most notorious. Yet judging by the growth in the number of visitors to exhibitions and museums of modern art, its popularity has never been greater. Between 1996 and 2000 the number of visitors to the Tate's annual Turner Prize exhibition, for instance, more than doubled, while a recent Matisse-Picasso exhibition broke Tate's records, and the opening of Tate Modern itself in May 2000 was the big success story of the millennium year. New art museums and galleries are opening everywhere to much acclaim, and with equally impressive visitor numbers.

Why this contradiction? Why on the one hand is there such bewilderment at, even contempt for, every latest publicly unveiled example of 'modern art', and on the other such a growing interest in the subject and the experience of it? These questions are central to this book, the primary purpose of which is to interrogate the *idea* of modern art – to explore why this art was made, what it means, and what makes it modern. And they lead on to others. Not *all* art that's been made in the last hundred years or so is accepted as modern. We need to explore the complex question of how the art that *is* selected as such, and that has until the late 20th century been defined as 'modern*ist*', relates to the dynamic cultural, social, economic, and political changes in the Western world that have been experienced as 'modernity' for the last 150 years. What has made a work of art *qualify* as modernist (or fail to)? According to whom, and just how has this selection been made? Does it continue to be so (what's the relation between modern and contemporary art)? And *whose* modernity does it represent, or respond to? Finally, the buzzword 'postmodernism': what does this mean for art? Is 'postmodernist' art no longer modern, or just no longer

modernist – in either case, why, and what does this claim mean, both for art and for the idea of 'the modern'?

As soon as we begin to explore this set of questions, one thing immediately becomes clear: the public's bewilderment at modern art has been a constant throughout the last 150 years – ever since 'avant-garde' artists started to challenge traditional art practices in a self-conscious and radical way. *Indeed the two terms are almost interchangeable: 'modern art' is, by definition, 'avant-garde' in its qualities, aspirations, and associations, while what 'the avant-garde' makes is, necessarily, 'modern art'.* This connection, then, is crucial, and it is therefore worth taking, as our starting point for this exploration, the question of the origins and meaning of 'the avant-garde'. The first aspect of this term that we might notice is the way, in common usage, it slips between adjective and noun – as in the italicized sentence above, in which the adjective 'avant-garde' refers to qualities, and the noun 'the avant-garde' to a notional community of self-consciously aesthetically radical artists. Distinguishing between these two will help us to understand the term better, because historically (to put it most simply) the adjective preceded the noun. That is to say, the qualities and aspirations of art that we call 'avant-garde' – art that sought to say something new in its time, to acknowledge the implications of new visual media, to stake a claim for aesthetic autonomy, or to challenge prevailing values – emerged, in the mid-19th century, before there were enough aesthetically radical artists to make up a community. That community itself emerged around the turn of the 20th century, and this is the moment when the word 'avant-garde' first became associated with new art, by its critics and supporters alike. The community quickly became a frame of reference for that art, its very existence influencing, in ways we shall examine, the forms that it took and what its meanings were taken to be.

The reasons why some artists began to have 'avant-garde' aspirations in the mid-19th century are complex. Summarizing broadly, we can say that the development of capitalism in modern

Western societies over the course of that century, and the steady encroachment of commercial values upon all aspects of the cultural practices of those societies, provoked some artists to seek to escape the conventions, the commodification, and the complacencies of an 'establishment' art in which those values were inscribed. Writers such as Baudelaire and Flaubert, and painters such as Manet, found their very existence as members of a materialistic, status-seeking bourgeoisie problematic – their distaste for such values not only isolating them from existing social and artistic institutions but also generating a deeply felt sense of psychic alienation. This double alienation, it has been argued, was the well-spring of avant-gardism. Yet there were other factors. It is no coincidence that these three individuals were French, for while France was not the only rapidly modernizing Western society, Paris was regarded as the cultural capital of Europe, with an unrivalled cultural bureaucracy, art schools, and career structure. Aspirant artists and writers flocked to the city from all over the world in the hope of grasping the glittering prizes it promised. Most were unsuccessful, finding their paths to fame choked by their own numbers and obstructed by protocols of privilege. So they sought alternative channels of advancement, exhibiting together in informal groupings, networking between their multiplying café-based milieux to promote, compare, and contest new ideas and practices, about which they wrote in a proliferating range of ephemeral little magazines, with consequences that we shall explore in Chapter 1, for this hive of activity was where both avant-garde art and the avant-garde community – and thus, 'modern art' – had their origin.

Yet the alienation the avant-garde felt was not a one-way experience. Fundamental to the bewilderment that underpins much public response to modern art is a suspicion of its sincerity, of the viewer being 'conned' or being found wanting – of this art being made by artists hungry for notoriety and sold through dealers whose main interest is in making money – a suspicion that is only heightened by revelations of the role of conspicuous art dealers and/or collectors such as Charles Saatchi in its promotion and

display. And it is no coincidence *either* that the modern art market that emerged around the turn of the 20th century did so alongside avant-garde art and the avant-garde formation, indeed as a major support of both, *or* that this market should have been led by venture capitalists. The motors for its emergence, however, were not mystification and profiteering, but two other factors that were central to the growth of Western capitalism itself: individualism and the rage for the new. Artistic individualism, in particular, was a quality increasingly cherished as bureaucratic and commercial structures and relations came to govern more and more areas of social life; artistic creativity became emblematic of higher values – 'the soul of a soulless society', to adapt Marx's epithet on religion – even for the bourgeoisie who were the chief architects of that society; and 'genius' became its supreme accolade. This development was registered in the market for modern art, in a shift in the attention of that market, after the mid-19th century, away from finished canvases (exhibited in their thousands at annual public exhibitions) to artistic careers in themselves: in the mid-1860s the Parisian dealer Durand-Ruel bought the entire contents of painter Theodore Rousseau's studio – preparatory sketches, studies for paintings, and all, since even such jottings were the traces of that artist's creativity. The more idiosyncratic (or 'avant-garde') the work produced, perhaps the more unfettered that creativity and the individualism it expressed; at least the possibility was worth betting on, for Durand-Ruel's investment turned out eventually to be shrewd, and he was followed quite soon by increasing numbers of dealers and collectors who sought out and backed promising unknowns, thereby demonstrating not only their faith in genius but also their own individual discernment in recognizing it. Such were the activities and interests through which a cultural space was created for Picasso – the typical modern artist of genius – eventually to fill. *Somebody* had to, after all, as I shall argue later.

From the start of the 20th century, then, the notion and the community of the 'avant-garde' artist sustained art practices whose

self-conscious transgressions of prevailing assumptions of what was aesthetically, morally, or politically acceptable were at the same time a guarantor of the individualism that was fundamental to modern Western ideology. In their different ways, artists such as Van Gogh, Picasso, and, later, Jackson Pollock enacted the individualism that all aspired to, plumbing those depths of human subjectivity that were beyond the reach of capitalist social relations – confirming what the philosopher Herbert Marcuse called the 'affirmative' character of culture in general, by at once consoling us for, and making good, the limitations of these relations. It has been this self-image as heroic explorers of the boundaries, the new and the overlooked aspects of human experience, on behalf of *everyone* that has characterized the avant-gardism of modern artists (and has fuelled the explicitly oppositional politics of many). But it has also placed them, and the art they have produced, in a triple paradox. First, because the starting point for many of these explorations has been a questioning of the materials, conventions, and skills of art practice itself. This questioning has been conducted via a range of gestures that has run from the iconoclastic, such as Picasso's use of newspaper and wallpaper, old tin cans, and other junk to make his collages and sculptures (Figure 10); through the provocative, as in Pollock's abandonment of paintbrushes, oils, and painterly dexterity for the crudeness of household enamel poured straight from the tin (Figure 7); or Warhol's deadpan adoption, in his soup can prints and brillo box sculptures, of the impersonal techniques of advertisement billboards and packaging; to the blatantly challenging, such as Duchamp's nomination of a urinal (and, more recently and exotically, Hirst's nomination of a dead shark) as a work of art (Figure 1).

And this questioning has posed an affront to established values, unerringly alienating that 'everyone' in whose name it was, purportedly, undertaken. Indeed, in the case of the surrealists, this paradox was posed in its extreme form, since such affront was precisely what a surrealist image or gesture was intended to achieve: for it was only through the 'convulsive beauty' of their

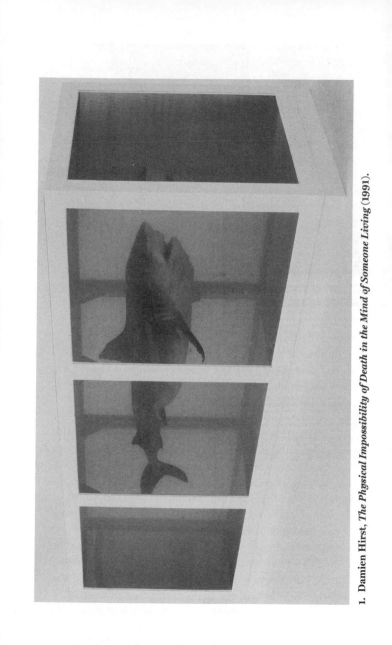

1. Damien Hirst, *The Physical Impossibility of Death in the Mind of Someone Living* (1991).

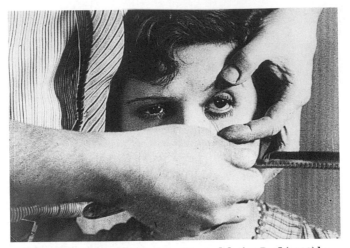

2. Film still from *Un Chien andalou* [*An Andalusian Dog*] (1928) by Luis Buñuel and Salvador Dali.

shocking, irrational actions or juxtapositions (Figure 2) that the complacent tyranny of 'reason' could be challenged – and the floodgates opened to those unconscious drives whose acknowledgement and assimilation alone could make modern human beings whole.

A second paradox: in the case of the surrealists and other self-consciously 'avant-garde' groups, the esoteric nature of the ideas and knowledge to which they often appealed, and the 'difficulty' of the images and objects they made – the resistance of an abstract painting by Mondrian, say, or a minimalist object by Morris to any easy interpretation; their refusal to offer any obvious 'meaning' – carried inescapable associations of a cultural elitism that fatally undercut any claims to populism the artists themselves might have mounted. It is true that much avant-gardist behaviour was public in character. The issuing of manifestos, which was one of its most notorious and influential innovations, and the mounting of provocative exhibitions (the Dada and surrealist artists excelled in

this) were aggressive promotional strategies aimed at the general public. Marinetti's 'Founding Manifesto of Futurism' was published in February 1909 on the front page, no less, of *Le Figaro*, one of Paris's leading daily papers of the time. But its real audience was private, and restricted. Those who had access to the meanings of its art were inevitably few, and they came largely from the milieux within which this art was generated. Moreover, while the network of modern art's *aficionados* grew steadily through the 20th century, so too did its aloofness and exclusivity, for the investment of such patrons was as much in that art's association with qualities of independence of taste and individualism, as in its future monetary value. As the American mid-20th-century critic Clement Greenberg put it, avant-garde art was, from its first appearance, connected to its patrons by 'an umbilical cord of gold'. How this relationship (and the ways in which artists negotiated it) shaped the character of modern art – and whether it will continue to do so – are questions we shall explore in later chapters.

A third paradox is that the self-image of the modern artist as cultural hero, acting on behalf of society to guarantee our individualism and renew its means of expression, is one whose gendered character has excluded one half of that society from its own ranks. As art historian Carol Duncan observed 30 years ago, the behaviour, art practices, and creations of early 20th-century vanguard artists were grounded in a widespread culture of masculinism: from the prevalence of the female nude as subject in painting and sculpture, via the socially regressive sexual relations that typified a 'bohemian' lifestyle in which women were mistresses and muses but rarely equals, to the aggressively attention-seeking, self-promoting tactics that the furtherance of an avant-garde career entailed, 'modern art' and the modern artist were so defined as to exclude women artists. There were exceptions, of course, but not many, and the century-long struggle of women to win equality with, and independence from, men in modern Western societies was also waged to some effect – but not much, as we shall see – in the arena of modern art, over the next 50 years. The efforts of the women's

movement in the USA and Europe in the 1970s and thereafter have, however, gained considerable ground for women in the art world, and (thanks in part to the work of Duncan and other feminist historians and critics, such as Linda Nochlin in the USA and Griselda Pollock in Britain) the work of women artists past and present is now becoming more visible. How that greater visibility has altered, if at all, the self- and public image of the modern artist is another question to return to.

Inseparable from the individualism of the modern artist has also, of course, been 'his' originality: as with the term 'avant-garde', to be modern, art has to be original in some respect. Over the century and a half since the emergence of modern art this originality, and the drive for it, have, however, been at once an expression of the independence of what has come to be called modern*ist* art from establishment or mainstream culture – indeed, for many, of its opposition to that culture – *and* one of the main motors of cultural 'modernization' in Western capitalist societies. It is, again, no coincidence that the decade before the First World War saw the consolidation both of the formation of the avant-garde and of the advertising industry in most of these societies. French art critic Camille Mauclair explicitly linked the two in a 1909 essay, charging the 'prejudice of novelty' for many of modernity's ills, and finding the same use of promotional hyperbole in the marketing of new art and new appliances. He might have mentioned too the growing two-way traffic, between art and advertising, in new visual techniques and languages, such as photomontage and graphic design; certainly a decade later these crossovers were commonplace, and avant-garde artists across Europe, from Sonia Delaunay in Paris to Alexandr Rodchenko in Moscow, worked simultaneously in both fields.

Yet if modern art and modern consumer products were both marketed by similar means, this was initially much more successful in the latter case than in the former. In the 30 years from 1900 that saw revolutions in the technologies of the design and

production of consumer goods, and in the means of creation of demand for them, avant-garde art remained on the cultural margins; its unorthodoxies remained beyond the pale of mainstream taste. This too was soon to change, however. The social base of modern art began to broaden at about the same time as its cultural headquarters moved across the Atlantic, from Paris to New York, in a development for which the consolidation of the USA's economic and political hegemony and the threat from Hitler that drove avant-garde artists from Europe shared much responsibility. The foundation in 1929 of the Museum of Modern Art in New York, largely with Rockefeller money, was the fairly modest first indicator of this broadening, and the steady growth in that institution's cultural assets, prestige, and influence over the subsequent three-quarters of a century has both registered the gradual assimilation of modern art into the leisure – and, more recently, entertainment – industries of Western societies, and provided a model for other museums in many of these. In recent years 'modern' art has not just come in from the cold, but – as the proliferation of those museums and the rise in their attendance figures that I noted earlier testify, and the celebrity status bestowed on individual artists (such as, for now, Tracey Emin) underlines – it has been fully assimilated into what the cultural critic Guy Debord called 'the society of the spectacle'.

Perhaps, though, I should say 'reassimilated'. Because, as I noted, 'modern art' began partly as a reaction against that very collapse of art's values into spectacle and commerce that characterized 19th-century academicism. Perhaps the founding moment of modern art was the 1863 Salon des Refusés in Paris, when a selection of the paintings that had been rejected by that year's jury for the official exhibition, or Salon, of new 'establishment' art was allowed an alternative Salon of its own – and the public, of course, a clear licence to indulge in uproarious and ribald ridicule of 'bad' art. The 'star' of this alternative exhibition, drawing by all accounts bigger crowds and more mockery than any other exhibit, was Edouard Manet's *Le Déjeuner sur l'Herbe* [*The Picnic Luncheon*] (Figure 3).

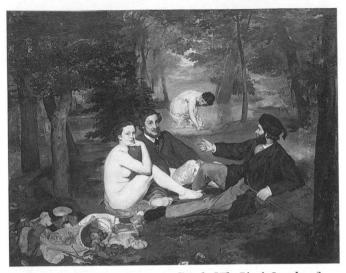

3. Edouard Manet, *Le Déjeuner sur l'Herbe* [*The Picnic Luncheon*] (1863).

Exploring why it was, and what this implies for the assumptions of its first viewers about art and their relation to it, will help to clarify the qualities that made (and perhaps still make) art 'modern'. First, we can imagine how the contemporaneity of the scene – the modern clothes of the men, the familiar picnic ingredients – might have seemed to those viewers to 'send up', even as it situated itself within, the tradition of such men-with-nude-women paintings. Even though old masters such as (say) Giorgione or Raphael, whose works in the Louvre might have been familiar to this audience, also painted their male figures in contemporary dress, that dress was no longer contemporary for these mid-19th-century Parisian viewers, for whom such paintings carried the aura of old master art, and to attempt to 'update' the tradition in this way might have seemed nonsensical, and suggested incompetence on Manet's part. Equally disconcerting, perhaps, was the woman's gaze: directed out of the picture and at the viewer, it both ruptures the illusion of the scene she is in, and addresses (and thus accentuates) the subjectivity of

the viewer. This fatally undercuts any narrative conviction that the scene might have carried, leaving that viewer both more self-conscious and uncertain about what the picture 'means' – and when we notice the little goldfinch hovering at the top centre of the picture, the assumption that the leading male figure's pointing finger is a gesture related to what he is (presumably) saying is countered by the possibility that he is instead holding this finger out for the bird to perch on. Absurd though it is, this ridiculous alternative is enough to collapse still further the narrative conviction, and correspondingly to heighten the sense that the painting mocks both old master art and its audience. And as if such undermining of conventions of pictorial staging and narrative weren't enough, the absence of convincing modelling of the figures (of the nude woman in particular, who seems inappropriately flat and bright, as in a flash photograph), and the inconsistencies of scale and perspective between the foreground group and the woman in the background, call attention to the materiality of the painted surface, and to the devices and conventions of illusionism itself. For a mid-19th-century audience, this too would have signified incompetence on Manet's part; yet troublingly for such an audience, there's sufficient evidence of competence to unsettle this assumption – and to heighten still further the sense of mockery.

Le Déjeuner sur l'Herbe managed to call into question all of the assumptions that underpinned the enjoyment of art by its Parisian public in 1863; or to put it another way, it failed to meet the established criteria for an acceptable picture, in ways that were either laughable or offensive. No wonder it was ridiculed by its first audience. But from our perspective, those assumptions and criteria are not so certain as they were: in a world whose visual culture is no longer dominated by painted images, in which the cultural hierarchy that placed pictures at its apex is under siege, if not fatally undermined, by the diversions of an endlessly expanding range of commercial popular visual media, it seems reasonable to propose, as Le Déjeuner sur l'Herbe seems to, that the specificities of *painting* – as a medium, as a practice, as a visual experience – need

to be taken into account in any representation of the visible world that it offers. For Manet perhaps first, but for generations of artists after him, the recognition that a picture was not a window onto that world but a *constructed* image of it, one that used devices and conventions of representation whose meanings were no longer as secure as they were once thought to be, would be the prerequisite of any attempt to say, in paint, something worth saying about the modern world – of any work, that is, that laid claim to the term 'modernist'.

Which brings us, perhaps, back to Rachel Whiteread and her *Monument*. It's possible to see the comments of the *Daily Mail* and the members of the public it quoted as standing in the same relation to this sculpture as Manet's audience stood to the *Déjeuner sur l'Herbe*. We could see them, that is, as bringing to their interpretations of the work assumptions about what a monument should look like, that *Monument* fails to meet – and which, like Manet's painting, it calls into question on a number of levels, by putting 'monumentality' itself into the equation. But this would be to assume, in turn, that nothing has changed since Manet. I think it has, and that things are more complex than this equivalence between then and now would suggest. The following chapters will try to explain how, and why.

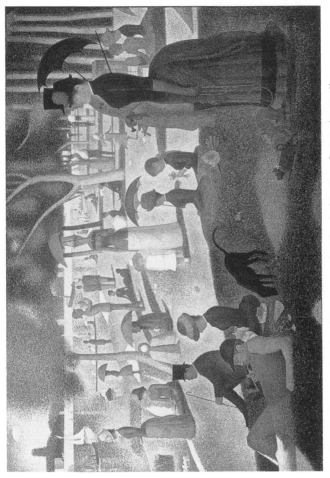

11. Georges Seurat, *A Sunday Afternoon on the Island of La Grande Jatte* (1884–6).

Chapter 1
Tracking the avant-garde

Origins and attitudes

When Emperor of France Napoleon III set up the 'alternative' Salon of rejected artworks, the 'Salon des Refusés', in Paris in 1863 he was, in effect, belatedly acknowledging a social and aesthetic development that was already underway: the accelerating increase in the number of artists wishing to make a career in his capital, and needing to exhibit in the annual Salons as a means to that end, and the proliferation of aesthetic interests that they were displaying in their works (the majority of which were failing, evidently, to impress the Salon jurors). This development was paralleled across Europe, as one feature of a widespread rise in the status and profile of the cultural professions, but it was in Paris, with its unrivalled artistic reputation and prestigious cultural institutions, that it was most acute. Aspirant artists flocked to the city from all over the world, especially after the collapse of Napoleon's empire in 1870, the establishment of the Third Republic that followed, and the reforms of the state's apparatus of cultural regulation and control that it introduced – as a part of which, artistic education was overhauled, and censorship and licensing of the press and the entertainment industries were loosened. By the turn of the 20th century, it has been estimated, the number of artists in France (most of whom were in Paris) had nearly doubled, and that of journalists and 'men of letters' had trebled.

But many of the newcomers found themselves deceived by the new Republic's promises of equality of access to fame and fortune, and their paths to career advancement obstructed by the realities of class hierarchies and professional protocols. It took more than a few new pieces of legislation, they discovered, to change the settled customs, privileges, and prejudices of generations. Thrown back on their own devices, they instead created new means of support for themselves and outlets for their work outside the mainstream of academically sanctioned art, in and around the newly liberated sectors of journalism and entertainment. Private art academies mushroomed, initially complementing (and preparing their clients for) the state art schools, but eventually taking their place; artists' groups used cafés and cabarets as their bases, exhibiting their work in them, as well as in the offices of the proliferating 'little magazines'. There were nearly 200 such magazines circulating in Paris on the eve of the First World War – publications whose writers made their names in these seething milieux by reviewing the new art that they incubated. Within a generation – by the time of the First World War – Paris had spawned a counter-culture whose vitality and hectic networking were registered in the scores of artistic and literary 'isms' that it generated. These 'isms' functioned as aesthetic trademarks, unrecognized (indeed ridiculed) in the mainstream, but sanctioned by this emergent 'avant-garde'. The term was claimed by its members at that time – who borrowed its implications of advanced status, of being 'ahead of the game', from an original military usage that had already been broadened into political discourse – as a means of compensating themselves for the social and cultural marginalization that they were experiencing.

Shut out of the mainstream and its material rewards, many self-styled avant-garde artists also channelled their idealism not only into experimentation with their chosen medium and its possible new modes and meanings – a matter to which I shall return – but into a belief that art had a public role to play, that it could be lifted from the status of trivial and anecdotal entertainment to which it had sunk in the Salons. Indeed, this commitment to a public art was

integral to the founding gesture of avant-gardism: the launch of 'neo-impressionism' in 1886. Its members had been among those who had in 1884 created the Society of Independent Artists, the main purpose of which was to hold an annual exhibition in Paris each spring that would be unjuried, and open to all. The '*Indépendants*' was, as a result, quickly to become the showcase for the most adventurous art of the next quarter-century. Two years later the leading painter in the group, Georges Seurat, exhibited his huge picture *A Sunday at La Grande Jatte* (Plate II), alongside smaller works painted in the same 'pointilliste' style by half a dozen other artists, in what was to be the last impressionist group exhibition. Inescapably public both in scale (no drawing-room could hold it) and in subject matter (a cross-section of Paris's contemporary inhabitants at leisure on one of the city's favourite river islands), its stiff formality, considered compositional geometries, painstakingly systematic brushwork – and its more than a hint of caricature – marked it off from the work of the older impressionists. The painting thus declared itself, and was taken as, the 'manifesto' of a new approach to art, one that sat astride two of the paradoxes I outlined earlier. For it was *both* a clear return to traditional values in painting that both Salon artists' anecdotalism and the informalities of the impressionists' pictures had discarded, *and* a new departure in painting technique whose machine-like regularity of brushwork and pedantic separation of colours seemed to ape, absurdly, modern mass production and scientific knowledge – thus, a picture whose supposedly public, even populist, mode of address seemed, to a contemporary audience, fatally undercut by its specialist and perhaps mocking novelties of style. Like Manet's *Picnic Luncheon* of 20 years earlier, but now from a declared 'neo' position, it managed to alienate, and to register alienation, at the same time.

The early years of the avant-garde established the key features of modern art and its relation to the public. But the emergence of that avant-garde was not confined to Paris. In every major city across Europe, and to an extent in the USA as well, similar communities of

anti-academic artists sprang up in the years before 1914, like mushrooms overnight – the by-product, as it were, of the process of social and cultural 'modernization' in the advanced capitalist countries of the Western world. By 1914 there were such communities in every major city from New York to Moscow, from Rome to Stockholm; a book published in 1974 simply listing the modern art exhibitions held in these cities between 1900 and 1916 filled two volumes. Artists and artworks, and their associated art critics and collectors, criss-crossed the continent, and increasingly the Atlantic, comparing and disseminating their ideas, producing not only an alternative 'art world', but one that came steadily to dislodge from its position of pre-eminence an art world centred on Salons and other official art institutions. And at its centre, generated by and generating it, were two driving forces. The first of these was a spirit of competitive innovation – a *rage* for the new, even – that was expressed not only in art practices and experimentation with expressive means, but also in strategies of organization and promotion: the 'isms' that proliferated so bewilderingly; the manifestos, events, and provocations that have come to be synonymous with 'avant-garde' behaviour. The second was a spirit of internationalism that sat uneasily with (and sometimes acted to mitigate) the rampant nationalism of the time – for the members of this community, their sense of national identity was qualified in complex and often contradictory ways by their avant-gardist affiliations. Between 1912 and 1914 the avant-gardism of the Italian futurists led by Marinetti, and in England the vorticists led by Wyndham Lewis, exemplified this contradiction: each group outdid the other, not only in its aggressive self-promotion and declaration of commitment to the modern world of steel machines, but also in its patriotic attachment to traditional national values.

For many artists, these affiliations and their implications so outweighed the appeal of nationalism, in those years of catastrophic conflict between nation-states, that they found expression in outright opposition to the social order that had brought the world

to war. Thus artists of the international 'Dada' movement (the meaning of the name is uncertain, and may be an imitation of a baby's babble) sought in different ways to mock, outrage, or vilify bourgeois society into its grave. In Zurich and Paris, Hugo Ball, Emmy Hemmings, Tristan Tzara, and others attempted this with cabaret performances and art exhibitions in which chance, absurdity, profanity, insulting and even assaulting the audience were key devices. In Berlin, George Grosz, John Heartfield, and others worked with the political Left, producing artworks, cartoons, and propaganda material that sharply satirized post-1918 German society. Less overtly political but also subversive, Marcel Duchamp in New York conducted a virtually solo campaign of calling into question the status of art and its relation to language, and the role of the artist, nominating a series of 'ready-mades' as art. The first of these, the *Bottlerack* 'made' in Paris in 1914 (Figure 4), was followed by, among others, a coat-rack nailed to the floor entitled *Trap*, and a urinal entitled *Fountain* (this last was entered – and refused by the jury – for a New York avant-garde art exhibition).

Artists in other 'isms' were equally subversive. In Paris from the mid-1920s, artists of the surrealist movement, founded by poet and essayist André Breton, took the antisocial gestures of the Dadaists and built on them a set of principles that directly challenged the suffocating 'rationality' of bourgeois society. Their art would be the means to break open its grip on the human imagination, liberate desire, and make us whole again; any object, text, or image that – wittingly or unwittingly – served to assist in this was celebrated for its 'convulsive beauty' (Figure 2). In Mexico, former adepts of advanced Parisian picture-making such as Diego Rivera, returning from Europe to find a revolution had occurred while he was away, abandoned the complexity and sophistication of cubism in favour of a revival of narrative fresco painting, putting modernism to the work of marshalling uplifting images for an illiterate peasantry. And in Moscow and St Petersburg the constructivists, fired by the aesthetic revolution of cubism and the iconoclasm of futurism, and

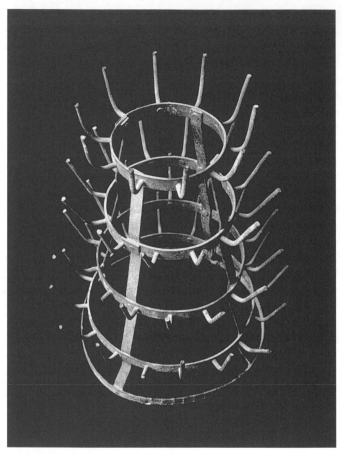

4. Marcel Duchamp, *Bottlerack* (1914).

driven by hatred of the conservative Tsarist regime, readily identified with the political revolution of the Bolsheviks and sought both to express its Utopian ambitions in their art and to adapt their artistic practices to the task of building the new society. Art, even avant-garde art, was bourgeois and redundant in their new Soviet Republic, and so, led by the example of Vladimir Tatlin,

'constructivism' became 'productivism': instead of making paintings and sculptures, its adherents made prototypes for useful clothing, furniture, ceramics, and textiles. Most ambitious of all their efforts was Tatlin's *Monument to the Third International* of 1920. Intended as a colossal steel and glass building, spiralling higher than the Eiffel Tower, that would have contained the legislature, executive, and commissariat of the new government all in one and would have projected the news on the night sky with its searchlights, the project never made it past the model stage (Figure 5). Nor, in the desperate circumstances of post-revolutionary, civil-war-riven, half-starving Soviet Russia, did it ever have a chance of doing so. But even as a model, Tatlin's *Monument* was such a potent symbol of avant-gardist Utopianism that it became instantly notorious, and has remained so into the present.

The accumulation of such initiatives, and the dissemination of their example around the increasingly self-supporting circuits of the avant-garde network through the middle years of the 20th century, helped shape an identity for the avant-garde artist as culturally independent, politically as well as aesthetically radical, and socially rebellious. And they shaped his or her art into a weapon for critiquing the dominant visual codes of modern capitalist society. So that by the mid-1980s, critic and art historian Benjamin Buchloh could define, and celebrate, avant-garde art-making as:

> a continually renewed struggle over the definition of cultural meaning, the discovery and representation of new audiences, and the development of new strategies to counteract and develop resistance against the tendency of the ideological apparatuses of the culture industry to occupy and to control all practices and all spaces of representation.

This definition raises some important questions. To what degree are that identity and this role mythic in nature – to what extent, that is,

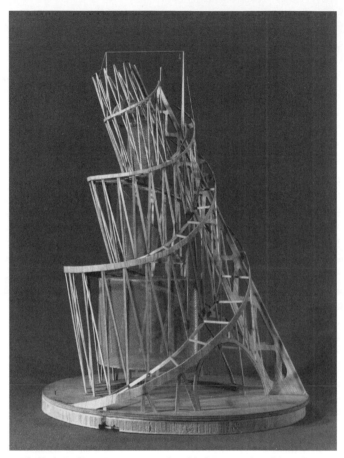

5. Vladimir Tatlin, *Monument to the Third International* (1920).

(and in what ways) have the many and varied lived experiences, and aesthetic positions, of anti- or un-academic artists been simplified, for society's own purposes, into a history of heroic cultural struggle? To what extent do the spaces still exist from which the practices that Buchloh celebrated can mount the resistance he describes? These are questions too complex for this book fully to resolve – but we

need to explore their ramifications if we are to understand how (and why) modern art and its meanings are produced.

On the one hand, many artists within the avant-garde community (or rather communities, in their different cities) in the middle years of the last century *did* pick up the mantle of resistance to capitalist culture and its 'apparatuses' from the productivists, Dadaists, surrealists, and their generation. Following such examples, they devised strategies to contest the turning of art into a gallery-based commodity, its institutionalization by increasingly powerful museums such as New York's Museum of Modern Art (MoMA); its exclusion, as 'high' culture, from the vitality of a burgeoning popular and commercial 'low' culture. In the mid-1950s USA, for example, Robert Rauschenberg and others mocked both rampant consumerism and 'high' art by making use of unusual materials, including a stuffed goat and rubber tyres (Figure 12) in 'assemblages' that not only picked up where Picasso's little constructions made of junk materials (Figure 10) had left off, but also anticipated Damien Hirst's most notorious ensembles (Figure 1). Claes Oldenburg rented a shop in 1960 in the down-at-heel lower East Side in Manhattan, where he offered for sale little paster-and-chicken-wire mock-ups of sandwiches, shoes, and other goods (nobody bought a thing), and staged performances or 'happenings' that were equally unsaleable. Late in the decade Robert Smithson, Richard Long, Michael Heizer, and others on both sides of the Atlantic expanded the field of art quite literally (and some of them sought to escape the constraints of the gallery) by making huge earthwork sculptures, or sculptures from natural materials that came to hand in hard-to-reach places. Through the 1970s such departures from, and challenges to, the institutional and market norms of art became, in the work of some artists, explicitly political. In Britain, Stuart Brisley and, in Germany, Joseph Beuys performed actions or staged events that sometimes mocked social and aesthetic conventions, and sometimes bitterly lampooned them. Beuys once gave an art history lecture to a dead hare cradled in his lap, and on another occasion lived for days in a bare room

with a coyote, while Brisley's performances included sitting on a theatre stage swallowing litres of water while a throne was built around him, and then spewing the water out to the strains of the National Anthem, as a symbolic attack on class structure and the monarchy. As the women's movement gained momentum in the same decade, increasing numbers of women artists, as well as art historians and critics, challenged the masculinism of avant-garde culture, and beyond it the injustices of patriarchy. In a series of wall-length, frieze-like paintings on paper made through the 1970s, New York artist Nancy Spero recovered and celebrated an almost-lost genealogy of female goddesses, alternating texts connotative of 'female' and 'male' speech with repeated images of goddess figures, suggesting an equivalence between embodied female identity and female writing. In the same decade another New Yorker, Carolee Schneemann, developed a style of performance art that celebrated the active female body, in a challenge to the conventional representation of this in art as passive. In her 1975 piece *Interior Scroll* she stood naked before her audience, gradually unravelling a scroll from her vagina, and reading from this a critique of her work by a 'structuralist film-maker' as too personal and cluttered with emotion.

Alongside the feminists, other politically radical artists made work that openly criticized the policies of art museums. None did so more directly and confrontationally than German artist Hans Haacke, in a series of documentary 'installations' in which he laid out the results of research he had conducted into aspects of the museums who had invited him to exhibit – material that tended to look embarrassingly like those museums' 'dirty linen'. In the case of the Guggenheim Museum in New York in 1970, the dirty linen that Haacke uncovered concerned the slum tenements owned by one of the museum's trustees; in response the Guggenheim cancelled the show, a move that backfired badly, as it led to charges of censorship, which generated much publicity of the wrong kind (as well as further spotlighting the behaviour of its slum-landlord trustee).

On the other hand, such oppositional gestures, however varied and inventive they were, could not halt the steady process of the co-option of the avant-garde, and of the art it produced, by those same mainstream forces that it opposed. Ironically, the Guggenheim cancellation did Haacke no harm at all: he found himself invited to conduct similar research by other museums, who presumably calculated that the possibility of him discovering shady dealings in their pasts was outweighed by the publicity surrounding the subsequent controversy – there being in the end, it is widely asserted, no such thing as bad publicity. So Haacke built a career on what might be called 'muck-raking' exhibitions – which did shed light on the dubious past practices and politics of specific museums, but whose political message was blunted, if not completely obscured, by the ways in which his work was 'framed' by those museums, and by the reputation for even-handedness that they gained in commissioning him in the first place. Such co-option, as this must surely be called, was by no means unique to Haacke. For, despite the avant-garde's cultural and social marginalization, those very motors that were driving its activities – the rage for the new and internationalism – were also driving modern, consumerist capitalism. As this consumerism was progressively extended through the mid-20th century, so the avant-garde became what one art historian has called the 'research and development arm' of the culture industry at consumerism's centre. The massive expansion of the Museum of Modern Art in New York over the half-century from its beginnings as the showcase of a couple of private art collections, into the most important collection of modern art in the world and the unrivalled arbiter of cultural taste, is indicative of this co-option.

Selling modern art

When Napoleon III set up that 'Salon des Refusés' in 1863, perhaps he did wish to reinforce the standards of the Salon jury, and thus of the academic system that regulated such careers, by holding up its rejects to public ridicule. This, at least, is how his gesture was interpreted for many years, by art historians for whom the

opposition between 'good' avant-garde art and 'bad' academic art has been a cornerstone of that narrative of modernism's heroic independence which still dominates popular understanding of modern art's history. But recent research has shown it to be more likely that the Emperor wanted to shake the Académie out of its complacency, and to give some encouragement to a broad spectrum of artists, by putting on such a rival display, a gesture in keeping with his general aim of encouraging entrepreneurship in all sectors of the economy, not least the cultural. Alongside his decision to set up the alternative Salon, Napoleon took measures to weaken the Académie's hold over art education, and to boost the status of design and the decorative arts. As Nick Green and other art historians have shown, his reasoning seems to have been that if a greater variety of artistic practices could be allowed to flourish, they would be able to meet the demands of an increasingly varied and expanding middle-class clientele with a multiplicity of pictorial and sculptural styles and products.

If this was Napoleon's aim, it didn't work out as he might have hoped – at least not immediately, since the combined resistance of the art hierarchy and the conservative tastes of that clientele put a banana-skin under the rival Salon. But that very conservatism, in the context of an expanding middle class, also left spaces, and provided opportunities, for art dealers with both flair and means to take risks on new artists. Paul Durand-Ruel was the most famous of the first of these, buying and supporting the impressionists through good times and bad from the 1870s, until the arrival of wealthy *nouveau-riche* patrons from the United States 20 years later secured his investment. His example was followed by a thin but widening stream of younger men, among whom were Ambroise Vollard and Daniel-Henry Kahnweiler – and one woman, Berthe Weill. Weill's feisty support of the new young artists she showed in her tiny Montmartre gallery in the early 1900s earned her the appreciative, punning nickname of '*la petite merveille*' [the little marvel], but it was Kahnweiler above all who brought new ideas and strategies to the business of selling new art when he opened his

gallery in 1907. Setting himself up ambitiously in the most expensive district of the Paris art world, Kahnweiler introduced contracts that tied 'his' artists exclusively to his gallery, and promoted them assiduously through that mushrooming Europe-wide avant-garde network I have outlined, cultivating a small but select group of discerning 'advanced' collectors.

The collectors, of course, were the key; without a willingness to speculate, on the part of enough people with sufficient money to do so, the new market would not have emerged. But the speculative opportunities grew more obvious with each decade. In 1904 a group of ten middle-class Parisian men formed a society to invest a small sum (3,000 francs) each year for ten years in the art of young unknowns, agreeing to sell their collection in 1914. They called themselves the *Société de la Peau de l'Ours* [Skin of the Bear Society], after a fable by La Fontaine in which two hunters sell the skin of a bear before trying – and failing – to capture the animal; thereby acknowledging their own speculative motives, and even enjoying the risk they were taking with their money. The sale in 1914 realized well over 100,000 francs; and it demonstrated that contemporary art could make its collectors money.

But money was not the only motive. As I have suggested, the discernment that collecting cutting-edge art required (or appeared to, as its dealers were quick to underline) reflected flatteringly on the collector and, costing less than the work of established artists, indicated his or her possession of as much independence of taste as disposable income. Even during the years of the First World War, there were enough (mostly US) would-be patrons of new art keen to acquire the reflected aura of individualism to sustain the art activities of non-combatant avant-gardists. After the War, the release onto the market of the huge cubist collections of Kahnweiler and Wilhelm Uhde that had been sequestered as enemy property (both were German) depressed the prices of these pictures drastically, to the despair of the artists who had created them. But it's an ill wind that blows nobody any good, for they were snapped

up for a song by a rising new generation of collectors, who thus found themselves owners of scores of works by Picasso, Braque, Gris, and Léger. In the meantime, certain collectors were deciding to take what seems, in retrospect, to have been the inevitable next step, and to found a museum (as opposed to a gallery) that would display their art – and thus their taste – to the public. The Museum of Modern Art was established, in 1929 in a house in mid-town Manhattan, for this purpose. It was the only public collection anywhere in the world devoted exclusively to modern art. Its trustees appointed as the Museum's first curator a young art historian, Alfred H. Barr, Jr, who brought with him not only a scholarly education but also an eye trained to make clear distinctions of both form and value. The appointment was shrewd, for this combination of qualities enabled Barr to undertake, by means of a series of themed exhibitions, the ambitious project of laying down a historical narrative of modernism that placed the Museum's collection at its centre. This both consecrated its artistic values and secured its position as arbiter of what was not just good or bad, but the most important art of the century. Some of Barr's exhibitions were such landmarks that they set the terms by which modern art was understood, and reshaped its chaotic eventfulness as a linear 'development', for the next half-century. The exhibition *Cubism and Abstract Art* of 1936 had a catalogue which has hardly been out of print since, and whose frontispiece diagram mapping that narrative (Figure 6) has been as reproduced as most of its exhibits.

Barr's appointment was also timely, for it came at the same time as the Wall Street Crash. Although art collectors seem not to have suffered greatly financially, the art market slumped until the mid-1930s. In this context the construction of a history for modern art, and of a canon (or roll-call) of the 'great' modern artists, was an invaluable bulwark against the loss of speculative confidence. Coincident, too, with the early years of MoMA was the growing threat of war in Europe. The greater familiarity with contemporary European art that Barr's exhibitions fostered was further enhanced

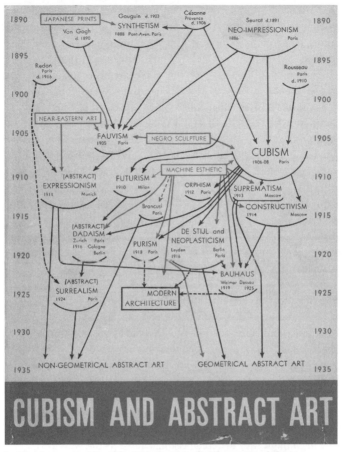

6. Chart prepared by Alfred H. Barr, Jr, for the 1936 exhibition catalogue *Cubism and Abstract Art*.

when scores of its most celebrated figures arrived in New York through the 1930s and into the 1940s in flight from Nazism and Fascism. The presence of artists such as Naum Gabo, Piet Mondrian, Fernand Léger, Salvador Dali, Marc Chagall, and Max Ernst consolidated the city's growing modern art industry, and enabled the emergence of new art museums and even a few

31

contemporary art galleries – as long as they were underwritten by patrons rich enough to absorb some early losses. The Guggenheim family, stupendously wealthy thanks to mining interests, held some of these: Solomon Guggenheim established in 1937 the Museum of Non-Objective Art that still bears his name (and whose recent challenge to MoMA's hegemony we shall explore later). In 1942 Peggy Guggenheim opened her Art of This Century gallery on 57th Street, showcasing work not only by the European émigrés but, alongside it, that by young New York artists too. By the time it closed in 1947 (and Peggy had moved to Venice, to start afresh there), Art of This Century had launched the careers of most of the pioneers of Abstract Expressionism, and had been followed by other contemporary galleries, whose dealers – Sam Kootz from 1945, Betty Parsons from 1946 – supported (and often subsidized) the work of the rising young generation of New York's newly international avant-garde.

The Abstract Expressionist movement was the first fully fledged artistic product of this avant-garde, and the process of its emergence and consolidation established, at the same time, New York's leadership of the international modern art world with MoMA as its headquarters. The city's art market by then had sufficient critical mass, in terms of the number of its dealers and its seriously wealthy collectors, and an associated corps of art critics – informed, ambitious writers (and sometimes artists) reviewing exhibitions, staking out positions, shaping the tastes of their assorted publics. The movement they fostered became known as the New York School. Some of these critics, above all Clement Greenberg and Harold Rosenberg, became as celebrated as the artists they wrote about, and (in ways we shall explore) perhaps even more influential. Underwriting their growing confidence and combativeness was a strengthening alignment between their cultural values and those represented as characteristically American in the postwar, Cold War world. No longer – it appeared – the standard-bearers of an oppositional aesthetics or politics, the paintings of the Abstract

Expressionists were paraded around the world as exemplars of the creative freedoms that were denied to artists in the Communist countries under Soviet rule. MoMA set up an International Program of Circulating Exhibitions in 1952, working, often with government agencies, to disseminate the work of the New York avant-garde, in shows such as *The New American Painting*, which toured Europe (and came to the Tate Gallery) in 1959. A far cry, this, from 1863 and the Salon des Refusés. Perhaps the apotheosis of the New York avant-garde formation and market came, though, in the next decade, as a succeeding generation of artists, dealers, critics, and collectors acknowledged the cultural authority of Abstract Expressionism in the time-honoured way, by overturning its precepts and abandoning its altars in favour of other religions. Pop art's (often ironic) celebration of the vitality of consumerist culture attracted new dealers like Leo Castelli and Ivan Karp, and new collectors such as Robert and Ethel Scull, and Emily and Burton Tremaine, whose voracious and well-publicized collecting activities – and, perhaps as significantly, their ostentatious unloading of their collections in the salerooms a decade later – enhanced the reputation of the New York market as much as they enriched its leading providers. When minimalist and conceptual artists made work, and followed strategies, in the late 1960s and through the 1970s that implicitly or explicitly critiqued the commodification of contemporary art that Pop and its handlers seemed to relish, these same dealers and collectors were happy to fund them – Scull backing the Green Gallery, showcase of minimalism, and Castelli adding Morris and Judd, its leading lights, to his stable, even though the anonymous, boxy, untitled objects that these artists made seemed light years away from the Pop exuberance that both the dealer and the collector had previously favoured.

Nevertheless, minimalist and conceptualist art proved harder to sell. Both 'isms' burst onto the art scene in the mid-1960s to critical acclaim, and the artists involved carried avant-garde authority – they were among the first whose art education was university-

based, and they wrote a lot about their own work. But it was, when all was said and done, not so much fun as painting and pop, and quite a number of major collectors gave up buying in the 1970s, causing the collapse of some galleries (such as Bykert in New York, which had focused on minimalism). Not surprisingly, therefore, leading players in the market sought to turn the tide, and within a few years they had done so: the early 1980s saw a return not only to conventional fine art media but to figuration too. 'Neo-Expressionism' was a loose and journalistic label for a group of painters working in a diverse range of figurative styles, whose rapid and simultaneous rise to prominence on both sides of the Atlantic – in Italy, Germany, and the USA – pointed more directly to the power of dealer cartels to control the contemporary art market than to any profound or widespread change in avant-gardist thinking (although the 'retro' preoccupations and pastiche manner that several of them shared had all the hallmarks of the postmodernism then becoming a buzzword). New names became familiar almost overnight – such as those of Sandro Chia and Francesco Clemente from Italy; Georg Baselitz, Rainer Fetting, and Anselm Kiefer from Germany; David Salle and, above all, Julian Schnabel from the United States. Alongside them, new dealers gained rapid prominence: among them Sperone Westwater Fischer, launched in Manhattan's SoHo by associates of Castelli from Frankfurt and Milan, and whose trilingual masthead epitomized the internationalism of this market-created art; and Mary Boone, who had worked for Bykert before setting up on her own, promoting Salle and Schnabel with such success that by 1982 she was being proclaimed (ahead – naturally – of her artists) as 'the new queen of the art scene' by *New York Magazine*.

The work of these artists, and equally of these dealers, was consecrated, after a fashion, by a major show at the Royal Academy in London in 1981. *A New Spirit in Painting*, cleverly titled to disguise its eclectic mix of blue-chip, early-century moderns, elderly make-weights, and the Neo-Expressionist 'transavantgarde' (as they were now termed), at once confirmed the ascendancy of neo-

conservative attitudes in the art world in the wake of the political victories of Margaret Thatcher and Ronald Reagan, and turned around the genteelly declining fortunes of its host institution. Perhaps equally important for the future of the art market, however, was its 'making' of the collection of Charles Saatchi, who had been investing in many of the artists represented in the exhibition, and who obtained a strategic position in that market over the next few years, publishing a glossy four-volume catalogue of his collection, *The Art of Our Time*, in 1984, and a year later opening his own huge exhibition gallery to show it, in Boundary Road, London. Although ostensibly a collector rather than a dealer, Saatchi had mixed business with pleasure ever since starting both his advertising agency (with his brother Maurice) and his art buying in the early 1970s, and by 1978 Saatchi & Saatchi the agency was reporting art sales of £380,000 for the year. At the start of the 1990s the precipitate expansion of the agency plunged it into debt, compelling Charles to sell art in large quantities – which he did just before the art market crashed: the sale of 200 works brought £23 million against an outlay of £8 million. Ironically, it was this sharp fall in art prices, coincident with the recession of the early 1990s, that further (if indirectly) strengthened Saatchi's strategic position in the market. He had exercised considerable 'leverage' on this market twice in the previous decade, in 1982 notoriously lending the Tate Gallery almost all of the exhibits in a show that it mounted of Julian Schnabel's painting – a gesture of acclaim by a major international public gallery that substantially enhanced the market value of these works – and a few years later unloading all of his many Sandro Chia paintings in a single sale that had a disastrous effect on Chia's prices. The immediate effect of the early 1990s recession was to unravel, to some degree, the international contemporary art network – in Britain, at least, where Saatchi is based, it was to 'reconfigure' British art to domestic concerns, and to foster the emergence of a more localized network of smaller galleries and warehouses, in London and other cities, where 'cutting-edge' art was shown. Saatchi's response was, uniquely for a collector on his scale, to acquaint himself with this emergent network, and, perhaps

with an advertising professional's 'nose' for a fresh scent, to pursue and purchase the edgy new art that was appearing across it: the work of young unknowns such as Damien Hirst, Tracey Emin, and Gavin Turk. The rest, of course, is history of sorts: the Royal Academy's *Sensation* exhibition in 1997 of this collection, and its establishment of the 'young British artists', or 'yBas', as a media phenomenon, and in some cases as art celebrities; the opening in April 2003 of the Saatchi Gallery, showcasing this work, in the prime tourist location (if awkward exhibition spaces) of the former Greater London Council building on the South Bank opposite the Houses of Parliament.

Indeed the location of the Saatchi Gallery was also a tacit acknowledgement of (and perhaps challenge to) the resurgence of the public art museum, epitomized by the colossal Tate Modern in the former Bankside power station just downriver from it. Although not too much distinction should be made between the public and private sectors of the art world – as art historian Chin-Tao Wu has shown, the two commingle closely, and the boards of trustees of the former are packed with the leading players in the latter (or their relatives) – it is the extraordinary flourishing of modern art museums across the globe in the last decade that has been the most spectacular feature of this art scene, eclipsing even the activities of collectors like Saatchi in its impact both on art's audiences and on its economics. To name but a few examples: the Guggenheim at Bilbao, designed by Canadian architect Frank Gehry and opened in 1997, is perhaps the most renowned, but it was preceded in 1996 by Brazilian Oscar Niemeyer's equally stunning art museum for Rio de Janeiro. Tate Modern, refurbished by the Swiss partnership of Herzog and de Meuron, opened in 2000, and was matched in 2004 by a much-expanded MoMA New York, the work of the Japanese architect Yoshio Taniguchi. The global character of this development is striking, but equally significant are two other features. In every case – as with the first of these 'postmodern' museums, the Centre Pompidou in Paris, designed by Renzo Piano and Richard Rogers, and opened in 1977 – the museum itself is its

own primary exhibit, not only supplanting the art in its collection as the main reason for visiting it, but upstaging that art with its scale and/or visual exuberance. Moreover, viewing the collection is understood, by these museums, as only one among several experiences they are now expected to offer. Others include those of shopping for books on, reproductions of, or merchandise decorated with the art in their galleries, and enjoying upmarket food in their cafés and restaurants. More and more, public modern art museums are thus being reconfigured as sites for consumption. (And with good reason: the MoMA's store, across from the museum, now makes seven times the sales per square foot of the average US shopping mall.)

The avant-garde today: dead or alive?

If modern art has become thus 'commodified' – co-opted by a culture whose driving force is the making and spending of money – does this mean that the 'avant-garde' as such is no more, and that its evolution into the research and development arm of the culture industry is complete? Not altogether: in three ways, and for three reasons, the term continues to mean something. First, if in the weakest sense, because in practical terms the sector of the art world to which the history of the 20th-century avant-garde gave rise – that of self-declaredly autonomous, experimental, self-referential art-making – still exists, with its specialist galleries, specialist magazines, and their still-impenetrable language, even if these are increasingly suffused by commercial values, as the Armani adverts in *Tate* magazine or Ernst & Young's sponsorship of blockbuster exhibitions testify. True, to claim avant-garde status for this market sector as such in any but the most neutrally descriptive sense is to travesty the meaning and the history of the term. Indeed, it has been noted by several cultural commentators that the co-option of the avant-garde by the market has achieved, but in dystopian fashion, that Utopian aim of the original avant-gardes to bring art back into social life. But the contemporary art world is not monolithic; some sectors of it are more autonomous than others,

and some of the motivations that shaped avant-gard*ism* as an ideology are still driving the making of 'cutting-edge' art. The idea that they were 'ahead' of mainstream society and its art (the original implication of the military metaphor) was always, for un- or anti-academic artists, partly a means of compensating for their marginalization and partly an expression of their commitment to a set of specialist, independent, and increasingly self-referential artistic practices. And this idea still holds: the art celebrities of the yBas aside, most of the graduates who emerge from art schools across the world every year with the ambition and means to continue to make art still experience the same marginalization, and share the same commitment. Few will succeed in financial terms, able to support their art practice from sponsorship or sales of its products alone, but the specialist training in working with particular materials, skills, and ways of thinking that a fine art – like any vocational – education has given them will (given that ambition and means) continue to shape their work, and the rich history of this specialism will underwrite their belief in its significance. We shall explore in the next chapter the complex set of aesthetic ideas and artistic 'isms' through which this commitment to making modern art has been expressed through the last hundred years. The fashion for 'isms' seems finally to have passed, but the exploration of possible new means and spaces of representation, inside and outside the culture industry, is likely to carry on.

There is, moreover, evidence of real and continued – if much diminished – opposition, of the kind that Benjamin Buchloh was celebrating in that remark I quoted earlier, to the tendency of the ideological apparatuses of this culture industry to 'occupy and to control' those means and spaces of representation. Although both the confident belief in the success of their resistance to capitalist culture, and the sense of participation in a broader movement of social and political emancipation, that fuelled the early 20th-century avant-gardes have withered along with the notion of a 'public sphere' of collective actions and identities in the harsh climate of recent and contemporary neo-liberalism, artists working

in a wide variety of media and from a range of positions, many of them in collaborative projects, continue to contest the hegemony of market values and the institutionalization of art practices. Michael Landy's 2001 performance work *Breakdown*, in which he methodically destroyed all of his material possessions, is a telling recent example. In Britain, that localized network of little galleries, warehouses, and other informal or 'unconsecrated' art sites, in London and other cities, that emerged in the early 1990s included artist-run collectives. These sought to evade the smooth but icy tentacles of bureaucratized museum curators surfing the cutting edge for material for high-concept exhibitions by showing their own work, much of it too ephemeral and too edgy for such purposes. Most prominent among them was BANK, a London-based group of artists who mounted exhibitions with titles such as *Cocaine Orgasm*, accompanying them with promotional material that combined slapstick and anti-art-world polemic in equal measure. A proposal BANK made in 2000 was that of 'closing down all public art galleries and redistributing public funds to individual artists' – to cut out 'curators, and status-mongers, and bureaucrats, and money-men and managers'. Other groups included Locus + , a Newcastle-based organization that commissioned predominantly time-based and site-specific work, and Nosepaint, another London collective that for three years in the 1990s ran monthly events involving over 300 artists' installations and performances.

For all the inventiveness of such groups, and their resourcefulness in operating on minimal funds, their avant-gardism has been caught between the market and marginality. As art historian Jonathan Vickery notes,

> BANK's argument can be read, paradoxically, as an argument for privatisation: public money fuelling the careers of private (and unaccountable) individuals, who will, no doubt – even if unintentionally – construct small networks of power and exclusion for their own personal gain and ensure the problems of funding on a macroeconomic scale are reproduced at micro level.

Indeed, nothing in its strategy or posturing prevented Saatchi from cherry-picking BANK artists for his collection. On the other hand, while time-based and site-specific work such as Nosepaint's has a clear line of descent from the radical art of the 1970s, it is also a product of a location on the margins of the art world: while the authors of *Occupational Hazard*, a valuable collection of writings on this ephemeral activity, celebrate Nosepaint events as 'a cross between a night-club and an art space [at which] people could listen, look and participate in art, certainly, but also drink, eat, dance and have a good time', this is a position, and a disposition, that risks collapsing critical art practice into mere carnival.

It does seem that, for the concept of an avant-garde within contemporary art, the game is nearly up. There is perhaps no longer any art able to identify and occupy spaces within the Western art world, and from them to deploy, in Buchloh's words, 'new strategies to counteract and develop resistance' to the controlling orthodoxies of the culture industry – the dominant visual codes of advertising, television, and Hollywood films. Given the saturation of our lives by their images, and the habits of sophisticated reading of these that we have acquired, any spaces from which they might be called into question seem all but closed up. But there are other factors than the avant-gardist inheritance of modern artists to consider, and other models of critical practice than that provided by the formation of the avant-garde. So I shall regard the jury as still out, on this question, and return to it at the close of this book.

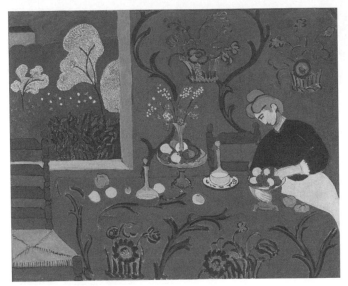

III. Henri Matisse, *Harmony in Red* (1908).

Chapter 2
Modern media, modern messages

At the start of the 20th century, art distinguished itself from what wasn't art by its materials as much as anything else. Oil on canvas, clay or plaster, bronze and marble were the consecrated materials for painting and sculpture, respectively; no other medium or practice, no matter how much skill it required or how inventive its pursuit, carried as much cultural weight, as much authority to give visual representation to the human condition. And thus it had been for centuries. Today, by contrast, it is difficult to think of a material that couldn't be – indeed, that hasn't been – used to make modern art of one kind or another: an artist's own blood, frozen (as in Marc Quinn's *Self*, his 1991 self-portrait bust); crowds of naked people (an art form pioneered by New York artist Spencer Tunick); chocolate (among others, Anya Gallaccio's *Stroke* of 1994, a chocolate sofa and wall-hanging); cigarettes (Sarah Lucas); office rubbish (Tomoko Takahashi (Figure 21)); and painting can now include even elephant dung, at least in Chris Ofili's work. This expansion of licence in the choice of art's materials has been, especially in recent years, so explosive that we might reverse the opening sentence above, to say that art today distinguishes itself from what isn't art by being able to be made out of absolutely anything. How has this situation come about, and what does it imply for the status of modern art, or its capacity to 'represent the human condition'? Does the art made today no longer have any claim to privilege in that capacity,

given that it requires no special materials – or is the nature of its medium no longer a criterion of the quality, or potential for profundity, of a work of art, let alone of its status as such? In which case, what does it now mean to make paintings, or sculpt in bronze, as opposed to making videos or installations, or portraits in frozen blood?

Painting and decorating: pleasures and principles

At the start of the 20th century, artists and their publics in the Western world faced a proliferation of visual technologies that was perhaps equivalent to that of the present. Where we in the West have DVD, CAD, and WAP to divert or bewilder us, our counterparts in 1900 were coming to terms with new means of photomechanical reproduction, chromolithography, and film – not to speak of new non-visual technologies of communication and transport based on electricity, radio waves, and the petrol engine. What was perhaps different was the *novelty* of the experience of having so many settled habits of vision and communication overturned at once – and at a time of unprecented expansion of the range of commodities that made use of the new technologies. In the context of this 'modernity', those artists, writers, musicians, and actors who by default or disposition found themselves outside the mainstream of their profession, in ways I have outlined in Chapter 1, directed their attention increasingly to the specificities of their chosen medium: to what made its meanings distinctive, and how these were made. They did so for a mixture of motives: to underscore this distinctiveness and enrich the unique qualities of each art form, in the face of a burgeoning commercial-cum-popular culture whose tendency was to submerge them in a tidal wave of perceived mediocrity; to explore the conventions and devices of visual representation, and to worry about the very communicability of these in the light of the new technologies; to put both to use in the service of their new societies. The results, which we shall explore in this chapter, were correspondingly diverse. Such concerns had a fairly long history, and had been constitutive of the professional

identity of artists for decades, but for the artists of the emergent avant-garde formations they became decisive. The first generation of self-conscious avant-gardists, that of the post-impressionists, for the first time since the Renaissance regarded the mimetic function of art – its adherence to visual reality – as less important than its symbolic or expressive function, or indeed than its formal harmony. Thus Van Gogh and Gauguin used rich and saturated colours not for visual realism but to convey directly by their intensity and interrelation a mood or an aspect of the meaning of a painting. Cézanne, too, brought up on impressionism's deep attachment to the look of things in the light of day, struggled (in, for example, his repeated and obsessive treatments of his local Montagne Sainte-Victoire) to reconcile the demands of this attachment with those of pictorial harmony, reducing his palette of colours to those that, while descriptive of their referent in the landscape, were also perceivably related in their contrasts or complementarities. The young spokesman for this generation, artist Maurice Denis, captured the gist of their concerns: 'It is well to remember', he wrote in an essay of 1890, 'that a picture – before being a battle horse, a nude woman, or some anecdote – is essentially a plane surface covered with colours assembled in a certain order'.

That Denis himself made a career as a decorative painter in the early 20th century, making screens and wall panels for the drawing-rooms of wealthy Parisians and friezes for the city's public buildings, is no coincidence. For this set of concerns with the 'formal' qualities of painting – colours, shapes, volumes, spaces, and their interrelations, independent of their mimetic value – brings it close to the sheer hedonism and visual pleasure of decorative surfaces such as carpets or wallpaper. This closeness has been, over the subsequent century, a source both of great richness for modern art, and at the same time of real anxiety for those 'formalist' artists and critics whose main concern has been to establish and sustain a pictorial modernism free from the contaminations of popular culture or social function. Thus for the American Clement

Greenberg, the most influential critic of the mid-20th century and chief architect of the formalist doctrine, decoration was 'the spectre that haunts modernist painting'. Because if painting was 'merely' decorative – if the formal qualities in which, for Greenberg, its profundity as an art form lay amounted to nothing more than visual pleasure – then there was nothing that distinguished it from the tasteful furnishings that featured in such magazines as *The World of Interiors*; but to the degree that painting relinquished representation of a world beyond its frame – as formalism implied that it should – it ran precisely this risk.

Yet for an artist such as Matisse, this dangerous ground was where the greatest potential of modern art lay. He saw that if they were no longer subordinated to their mimetic function, the illusionistic devices of painting (the capacity of marks and colours on a flat surface to create a whole fictional world of space and form, light and shade) were free to be a source of the deepest visual and intellectual enjoyment. His 1908 painting *Harmony in Red* (Plate III) set the terms in which he would cultivate this ground for the rest of his career. It is a highly charged painting, in purely visual terms: the intense red of the wall and tablecloth held in check by the blue arabesques of their patterning in a drama that insists upon the painting's flatness (and to whose dynamism the view out of the window is entirely subordinate). Yet this flatness is everywhere countered by clues to depth – although these are more conceptual in character than visual, and are often minimally stated. Thus we read the plane of the table-top without difficulty as horizontal, despite the unbroken battle between red and blue, partly because we are cued to do so by its right-hand edge and by its rear left corner, but also because we 'know' that the carafes, fruitbowls, and fruit depicted on it 'require' it to be, and their clustering in a band between the maid (who establishes one key pocket of depth) and the chair (which establishes another) provides just enough conviction for us to do so. This interplay between flatness and depth, line and colour, eye and mind, is both richly enjoyable and thoroughly characteristic of Matisse's art. The picture offers an oasis of

delightful artifice in the desert of the real, everyday world – which is why Matisse is so popular a hundred years after he painted it, and still relevant for contemporary painters and their audiences.

Not all modernist painting has been as sheerly hedonistic, in intention or outcome, as that of Matisse; indeed, most of it was the product of quite different concerns. 'Modernism' is a complex term – and 20 years of disagreement over the meaning of 'postmodernism' have made it more so. To put it most succinctly: as I suggested in the Introduction, modernist painting's common denominator, through most of the 20th century, was a recognition that a picture was not a window onto the world but a *constructed* image of it, one that used devices and conventions of representation (such as one-point perspective, or modelling with shadows, or geometrical systems of composition) whose meanings were no longer as secure as they were once thought to be, given the proliferation of new visual technologies that were calling them increasingly into question. This recognition was registered, and its ramifications pursued, in many different ways. While Matisse took evident delight in the games of make-believe that it licensed, artists of the cubist movement explored the ways and means of art's artifice for other purposes: those of articulating their experiences of modern metropolitan living, or their critical resistance to its seductions. For Picasso and Braque in particular, such exploration led to an understanding of painting as a sign-system that was much like language in its functioning. Paralleling to an uncanny degree the contemporaneous writings on language by Peirce in the USA and de Saussure in Geneva, they took picture-making back to ground zero before rebuilding it, creating a pictorial style characterized by flat, intersecting planar configurations that foregrounded and repeatedly subverted their own illusionism (Figure 11), and that in Picasso's inventive hands furnished a wholly new vocabulary for sculpture as well (Figure 10). Even more than the style itself, which dominated modern art-making across the avant-gardes of the Western world for a decade, cubist principles

and the experimental approach to painting from which they
originated provided the terms of reference for modernist art
practice for over half a century. The experimentalism was well
suited to a first generation of self-conscious avant-gardists:
Malevich and his suprematist disciples in Moscow and St
Petersburg; Mondrian and his colleagues in the de stijl movement
in the Netherlands; and the futurists in Milan and vorticists in
London, among others, took cubism as a foundation for their
different versions of new, non-representational (or 'non-objective')
art. The ubiquity of this model of art-making was registered, and its
historical pedigree established, in Alfred Barr's 1936 exhibition
Cubism and Abstract Art at MoMA in New York (Figure 6); equally
important, this event influenced a succeeding generation of artists,
in what would become modern art's new capital city.

With the distance of both a generation and an ocean from cubism's
innovations, however, the New York artists were in a position to
challenge, as well as absorb, the aesthetics of cubism. The bars,
clubs, and studios of SoHo were a crucible of ideas in mid-century,
and the forging of a coherent set of artistic practices that, in keeping
with avant-gardist principles, built on and went beyond European
modernism was as much the achievement of critics – paid to do the
work of summarizing, selecting, and predicting – as of artists in the
thick of things. Out of this crucible spilled two ways of making
modernist paintings in a radically new way, which critics hammered
into what they termed 'colour-field' painting and – more
contentiously – 'action painting'; together they made up what
came to be known as Abstract Expressionism, or the New York
School. Its most notorious artist was Jackson Pollock, championed
by Greenberg from the early 1940s as the best painter in America,
and the heir of the European modernists. What made him so,
for this critic, were the formal aspects of his emphatically flat,
increasingly large pictures, thickly covered with household
enamel paint dribbled from the can onto canvases laid on the
floor, in 'all-over' abstract configurations (Figure 7). Greenberg
championed in particular the way in which, as he saw it, Pollock had

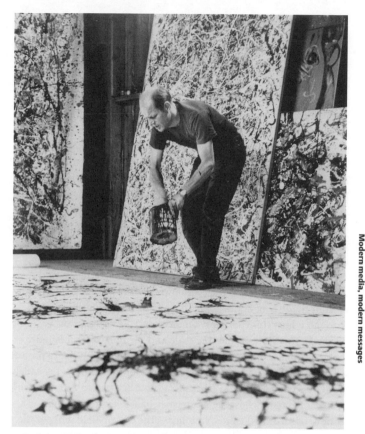

7. Jackson Pollock at work on *No. 32* (1950).

adapted cubist and post-cubist pictorial devices and the shallow,
surface-hugging space they created to make a radically different
kind of painting. This was different in scale, in its dissolving of
the distinction between line and colour, in its elisions of 'figure'
(i.e. shapes) and the 'ground' on which they were drawn and
painted. And yet what made these qualities so significant was their
pedigree: the way they followed an imperative that Greenberg
traced from Manet onwards to isolate and enrich painting's

unique formal properties. This was the high road of modernism, as he saw it.

Greenberg's interpretation of Pollock's work was hugely influential, both on a younger generation of critics and on the artists they wrote about in the 1960s and 1970s. But it now seems very reductive. What about the expressive power of these huge and complex layered skeins of paint? The energy with which they were made, the physicality of their sweeping gestures, and the performance – the 'action-painting' event – of which they are, in a sense, the record? None of these counted for Greenberg, yet as recent art historians have stressed, they did count for Pollock and his fellow artists. The 'Americanness' of these qualities were important for him, a boy from the 'big sky' country of Wyoming who was determined as much to break from as to learn from the refinements of European art. Indeed, it has been suggested that a key quality of many Abstract Expressionist paintings was and is their 'vulgarity': the tackiness of the colours, the overblown rhetoric (as it might be seen) of their manner of application, the machismo of their physicality, through which this (perhaps stereotypical) 'Americanness' is declared. Be this as it may, the scale and the uncompromisingly 'holistic' quality of many of these paintings often combine to project a sublimity that is beyond formalist consideration, and yet is widely recognized and enjoyed. Perhaps this is more the case with the work of Mark Rothko, whose signature style of stacked rectangular 'clouds' of saturated colour epitomizes the colour-field wing of the movement. The sheer beauty of some of these, and the haunting immateriality of their surfaces, have caught the art public's imagination more successfully than Pollock's 'drip' paintings, whose seemingly blatant rejection of painterly skill remains, to the unobservant at least, an affront to expectations of what art-making requires.

Yet the inadequacy of a formalist understanding of Pollock's, Rothko's, and other modernist paintings does not lie only in the fact that the interpretive possibilities that they invite are far in excess

of, far more richly and rewardingly plural than, its criteria allow. It lies also in the fact that modernism has been based, for the last hundred years, upon another recognition besides that of the 'constructed' nature of any representation. The turn-of-the-20th-century proliferation of new visual technologies that provoked this insight also made redundant the craft skills that until then were a necessary condition of quality in art. The ability to paint entailed competence in making a likeness of any given subject, in presenting a convincing illusion of a part of visual reality. If this could be done by machine – and Seurat's *Grande Jatte* (Plate II), with its formulaic application of touches of colour, presciently anticipating present-day televisual pixelation, clearly pointed to such a possibility as early as 1884 – then what made a work of art was no longer this *craft* work, but the *intellectual* work of conceiving it. As art historian Thierry de Duve put it, 'around 1913 painting as craft was replaced by painting as idea'. He suggested 1913 partly because that was the year in which avant-garde artists across the Western world took the decisive step into abstract art, and partly because it was when Marcel Duchamp in Paris constructed his first *Readymade* 'sculpture' out of two ordinary objects, a bicycle wheel and a stool, which he simply bolted together. Duchamp followed this a year later with a second *Readymade* that was simply a metal rack for drying wine bottles, nominated by him for 'art' status (Figure 4). Over the subsequent century, this *Bottlerack* has become, as a model for modern art, quite as important as the move into abstraction. It was as fundamentally influential as it was elegantly minimal, because it established with an absolute economy, like a geometrical axiom, the new principle that, in a culture in which art could be produced mechanically like any other consumer durable, it was only the *idea* that something was art that made it so. To put this another way, Duchamp exposed and made play with the intellectual conventions that underpinned art and that lay alongside those technical conventions exposed and enjoyed, in ways I've outlined, by Matisse, Picasso, and others. The intellectual conventions depended, in their turn, on assumptions as to the status of the

artist, which I shall explore in Chapter 3 – and, as we shall see, it's become clearer since Duchamp's original insight that, in the words of conceptual artist Michael Baldwin, 'modern art is more a product of its discourses than of its vulgar artificers'. In other words, art's status is more dependent upon social and institutional custom than upon the people who actually make it – individual artists – however innovative they may be.

The 'vulgarity' of Pollock's methods of painting, and their apparent abandonment of craft skills (though this can be exaggerated; Pollock became as dexterous in his pouring and dribbling of paint as he had been with a paintbrush), should not be understood, therefore, only in terms of their formal effects or innovations, or their expressive force, but also in terms of the *idea* behind this abandonment – as putting those skills specifically into question, as part of the meaning of the paintings. They did this in two ways. First, in restoring to the act of painting something of the rawness and psychic potential that were lost in the very acquisition of painterly skills, not just for expressive effect but as a means of evading the co-optive reach of mainstream taste. (Discussing a well-known set of photographs taken by Cecil Beaton in a fashion shoot for *Vogue* in 1950, of models posing in front of some of Pollock's drip paintings in frocks whose colours matched them, art historian T. J. Clark suggested that they epitomized the 'tragedy of modernism' precisely because they showed such evasion as doomed to failure.) And second, in their implicit reference, clearer perhaps to viewers at the time of their painting than to us now, to the 'automatist' techniques of the surrealist painters. These techniques were strategies of the abandonment of control of the creation of an image – via random spattering of paint on the canvas surface, doodling with eyes closed, and so on – by means of which artists such as Max Ernst and Joan Miró sought to access the unconscious, and to give it a central role in the making of visual meanings, and thus in our mental life. For Pollock too, like most of the other Abstract Expressionists, was fascinated by the unconscious and by our instinctual drives; in the immediate postwar, post-Hiroshima years,

this was a widespread theme in contemporary culture. Yet unlike the surrealists' programmatic pursuit of the 'liberation' of the unconscious, this concern opened into a wide-ranging engagement with the non-rational: in Europe and America, artists such as Wols, Karel Appel, Ellsworth Kelly, Robert Rauschenberg, and composer John Cage explored, in very different ways, the role of spontaneity, chance, and accident in the making of art and the representation of their subjectivity, borrowing from Eastern philosophies as much as from psychoanalysis in doing so.

Formalist art criticism would have none of this, and Greenberg's unrivalled authority as a critic gave those artists he supported a prominence that belied the strength of postwar engagement with such non-formal considerations. When a number of young art-historian critics began to extend and apply his doctrine from the early 1960s in a new and lively art magazine, *Artforum*, for the first time a self-consciously formalist 'school' of artists, furnished with a critical power base, came to dominate, briefly, not only the New York art scene but, by virtue of its vitality and financial muscle, the art centres of Europe as well. Among others, American painters Kenneth Noland and Frank Stella and British sculptor Anthony Caro made art that was abstract, angular, and brightly coloured (Figure 8), and whose meanings, systematically explained and elaborated by their critic associates, were based on Greenberg's doctrinal concepts of 'medium specificity' and 'opticality'.

They were imitated by art students across at least two continents, and for a short time in the mid-1960s Greenberg's 1961 collection of essays *Art and Culture* was an art school 'bible'. But it was to be a final flourish for this most influential of aesthetic doctrines. If Stella's insistence that in his paintings 'what you see is what you get' pithily captured the doctrine's self-confidence and reductiveness, the paintings themselves posed awkward questions, with their interplay between surface design and strangely shaped canvas, and their shamelessly decorative appearance. The formalists' imperative

8. Frank Stella, *Takht-I-Sulayman I*, from the **Protractor Series** (1967).

that a painting should declare itself as more than a decorated object – in their critical parlance, should 'acknowledge but also transcend its own objecthood' – was called into question, in ways and with consequences we'll explore later, by these sumptuous conundrums. Perhaps more important, though, was the mounting evidence that formalist art could no longer hold its own against the vitality, ubiquity, and expressive potential of that commercialized visual culture beyond its frame; within less than a decade, the citadel had collapsed.

Mixing media: from collage to installation

Even as the first-generation avant-gardists were exploring the distinctiveness of their chosen media *vis-à-vis* the new technologies of early 20th-century communication, they were also exploring the new possibilities these technologies offered. In ways that complemented the search for 'purity' that I have traced, or that entered into dialogue with it, or opposition to it, painters and sculptors seized on and put to use the pleasures of 'hybridity'. Governing this exploration were what can be summarized as two sets of concerns, which we could call those of 'co-option' and 'transgression'. Both were the product of the cultural marginality of the avant-garde, neither part of the mainstream of art practice, nor part of popular and commercial visual culture – yet still attached to the former (via exhibitions, dealers, art schools, etc.) and attracted, both as consumers and out of technical interest, to the latter. On the one hand, as art historian Tom Crow observed, sometimes painters 'raided' the popular and commercial arts of posters and photos, music-hall and cinema for the means to displace the lifeless formulae of academic art, and co-opted their devices or effects to replenish or update painting's box of illusionist tricks. On the other, as often, artists made use of hitherto non-art media precisely to disrupt such categorization, to break free of, or transgress, what seemed to them the pointless constraints of an outmoded cultural hierarchy, or to bring the oblique vision of aesthetic experiment to bear on new media.

Among the first of the new visual media to be explored in these ways was photography. It has been in conversation with painting, indeed, ever since its invention in the 1830s ('from today painting is dead', a French painter acknowledged, somewhat prematurely, in 1839), and the rollcall of artists who have joined this conversation in the last century is too long even to attempt to list them. For some, including Duchamp, the surrealists, 'new objectivity' painters of the 1920s, and painters of portraits and the figure such as Bacon, the dialogue between the two media was crucial, although it was one in which painting was the senior partner; in general, the devices and effects of photography have been co-opted for painting, rather than opening the way beyond it. This has not always been the case; German painter Helmut Herzfeld (who changed his name to John Heartfield in protest at his country's policies during the First World War) abandoned the medium in the 1920s in favour of photomontage, with which he concocted for left-wing newspapers the potent anti-Nazi images that made his name. Around the same time, artists as different as the American Man Ray, who was close to the surrealist group in Paris, and Moholy-Nagy, the Hungarian sculptor-cum-film-maker who taught at the Bauhaus in Germany, were taking the aesthetics of abstract painting into photography, experimenting with the non-representational possibilities of photographic images – each dispensing with cameras, too, making compositions directly on light-sensitive paper by exposing to light a wide range of objects placed upon it. Such 'photograms' (Man Ray punningly called them 'rayograms') opened up a whole field of experimentation that was exploited by numerous followers in subsequent decades.

But the attraction of artists to the mass-circulated photographic image grew rapidly with the huge expansion of this medium in magazines, television, and advertising from the 1950s, and the practice of painting has been considerably enriched through the resulting engagement with its techniques. After the high-keyed emotionalism and introspection of Abstract Expressionism, artists of the succeeding generation looked to the mechanized image as a

means of reconnecting with the world beyond their studios. For all the mundanity of their subject matter, Andy Warhol's screen-printed images of violent road deaths, suicides, and electric chairs in the early 1960s were uniquely and horrifically compelling in their juxtaposition of carnage with numbing repetition, grainy documentary photo with luscious colouring, the eternity of death with the frozen moment of its encounter. In his apparent abandonment of aesthetic control or decision beyond the staging of these, Warhol raised questions about the place of art in our image-saturated societies that critics and historians are still discussing. Less starkly staged, but more wide-ranging, the encounters with photography in which German painter Gerhard Richter has explored, over a nearly 50-year career, what it means to paint in a culture of the instant visual image have characteristically exploited the out-of-focus shot, rather than the half-tone of news photography. His painstakingly blurred images, whether of a favourite uncle in wartime Nazi uniform, or a head caught turning away (Figure 9), or – closest comparison with Warhol's *Disasters* – the corpse of a Baader-Meinhof terrorist gang member, carry multiple connotations: of family album, police archive or time-curled snapshot, of movement and moment, of an eye behind the camera. And these associations carry over into painting, translating into the particularities of this very different practice in ways that bring together the traditional dimensions of its uses (in portraiture, history painting, landscape, etc.) and its formal, hand-made devices, with a resonance that underlines the continued relevance of this art medium.

Perhaps the most radical of explorations of non-art media, however, and the most influential in the example it set, in both 'co-optive' and 'transgressive' terms, was Picasso's invention of 'collage'. This is the term given to his inclusion of fragments of newspaper, wallpaper, packaging, and other cast-off materials in two- and three-dimensional artworks. For a couple of years from 1912, when he first took this unprecedented step, collage was almost Picasso's sole preoccupation, so taken was he not only with its transgressive

9. Gerhard Richter, *Betty* (1988).

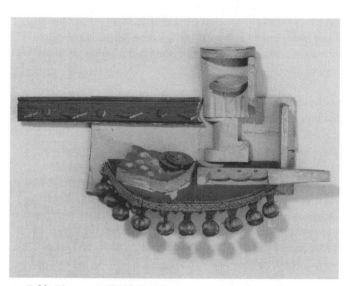

10. Pablo Picasso, *Still Life* (1914).

implications, but also its potential as a vehicle for testing and playing with the limits of illusionism. His *Still Life* construction of the spring of 1914 (Figure 10) is clearly a collection of humble materials: some scraps of wood and tasselled braiding, painted and arranged to look like a slice of bread and sausage, a knife and a wineglass on a table. Through this rudimentary likeness they create a fictional space – that of a café table beside a wall – and yet, jutting out into *our* space without any of the usual frame or pedestal, they call this fiction into question. At the same time, likeness itself is also undermined: for if the bread, sausage slice, and knife look real, the glass has something of the character of a diagram, its transparency and volume implied by the wooden arc of its lip, at right angles to its elevation; while the table-top slopes downwards, as if seen from above, and parts company with the glass that is supposedly standing upon it. In thus combining conventions of representation, Picasso points to their conventional character. Indeed, he does more: for while we may not be fooled by the bread and sausage, which are

identifiably made of wood, the braid *is* braid, of just the kind that edged many a tablecloth in 1914. Thus the borderline between fiction and reality (between what is art and what isn't) is also compromised.

Yet if this little work is delightfully transgressive – the very humbleness of its materials contributing to its wit – this is a transgression for which that borderline is a marker, not an obstacle. The point *is* the fiction, for it foregrounds Picasso's inventiveness. It may be this alone that makes the difference between art and cast-off scraps, but the difference counts. Picasso was quick to translate the terms of this wit *back* into oil paint, in works such as the *Still Life with Fruit, Wineglass and Newspaper* of summer 1914 (Figure 11) that make play, in their turn, with the appearance of collage – the cable-moulding of the table-edge looking as real as the braid in the construction made a few weeks earlier.

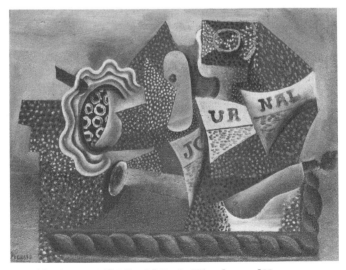

11. Pablo Picasso, *Still Life with Fruit, Wineglass and Newspaper* (1914).

This recuperation of scrap materials for aesthetic play opened up a whole new field of art practice, and from 1914 a generation of artists explored the interface between painting and printed ephemera. None did so more single-mindedly than the German artist Kurt Schwitters, whose endless yet inexhaustibly inventive production of collages of tickets, cards, adverts, news photos, and the like gave compelling expression to the modern city life in whose interstices, coat pockets, and kitchen drawers such items accumulate. Our haphazard rediscovery of them can act on our memory much like the taste of the madeleine biscuit acted on that of Proust's hero in *Remembrance of Things Past*; in Schwitters' collages such fugitive connotations are the warp of tissues of meanings whose weft is their textual interplay and surface design.

Such a combination of private reference and public engagement with painting's devices and conventions lies at the centre, too, of Jasper Johns' picture-making, though in a register much removed from Schwitters' fascination with 20th-century city living. In some paintings of the 1950s Johns juxtaposed 'ready-made' motifs, such as targets and the US flag, with rhetorically 'expressive' brushwork and with esoteric combinations of plaster-cast body parts – employing the collage principle to challenge both the strident subjectivity of then-fashionable Abstract Expressionism and the viewer's expectations of 'easy reading'. The resulting images were puzzling. Not only as to whether, say, *Flag* of 1955 was a painting *of* a flag or a flag *in paint* – an uncertainty that undermined a little the normally secure differences between a painting and its subject – but also in that the brushwork was 'expressive' to no purpose, entirely superfluous to the matter-of-fact image and correctly detailed design. Clearly, these weren't the first-person-singular declarations of 'New York School' painting, but something more ambiguous, even inscrutable. In Johns' subsequent work, from the mid-1960s on, which incorporated a steadily widening range of extraneous objects, including cups, brooms, and chairs, these qualities have become even more evident. Their engaging elusiveness of reference and the appeal of their

densely worked surfaces invite a reflectiveness of response on our part, whose reward is to enrich our understanding of how visual meanings can be construed from disparate marks, images, and associations – in short, of what might be called the 'poetry' of painting.

Yet if one avenue of exploration of the implication of Picasso's collage lay in the recuperation of it for the greater enrichment of modernist painting, another lay in the opposite direction: in dismantling, or breaking beyond, the constraints of the picture frame. The Spaniard's Paris studio was visited in 1913 by the young Russian artist Vladimir Tatlin, who took back with him to Moscow not only his excitement at the radical constructions he had seen, but the idea for an even more radical departure from their principles. The next year he made the first of a series of three-dimensional works that combined, like those of Picasso, discarded scraps of wood, glass, and metal, but which suggested no fictional object, theme, or space. Entitled simply *Reliefs*, they hung on the wall – or from 1915, as *Corner Reliefs*, hung suspended across the corner of a room – as simply themselves: 'real materials in real space', in Tatlin's slogan declaring their invention. Freed not just from any representational role, but from the very status of art objects, they could be taken as models for the carving-up of space, or for the juxtaposition of materials, colours, and textures. As indeed they were: after the Bolshevik Revolution of October 1917 which, like most members of the Russian avant-garde, he welcomed, Tatlin pursued the functional logic of such modelling so far as to abandon art-making in favour of the design of socially useful goods (clothing, furniture, etc.) based on the constructive principles they had proposed. With hindsight we can see in this rapid trajectory of Tatlin that development of 'product design' out of avant-garde art practices which was consolidated at the Bauhaus school of art and design, founded by architect Walter Gropius in Weimar, Germany, in 1926. But, of course, Tatlin's reliefs *were* art: not only because – like Duchamp – he said so, but because this declaration was part of an (avant-garde) art discourse, and the work was shown in an art

environment. Thus Tatlin could, in a way, have it both ways: break with art's consecrated media, and with its role of the fashioning of fictions, but not with art's status, as long as he acted as an artist. This was to be the liberty, but also the limitation, experienced by later artists who took up his mantle.

The liberty was exhilarating. Robert Rauschenberg began his career with a use of collaged materials that emphasized the 'ordinariness' of art objects and that, like Johns' contemporaneous work, mocked the overblown rhetoric of the Abstract Expressionists. In a series of red, and another of black, painted collages of fabrics and papers, which he termed 'combine paintings', the emotionality of these colours was denied by the mundanity of the materials by which they were exemplified. He quickly moved on to incorporate the most far-fetched items, such as a pillow and a stuffed eagle in *Canyon* of 1959, and a stuffed goat in a car tyre in *Monogram* (Figure 12). In the latter, too, the removal of the painting from the plane of the wall to that of the floor signified more than a witty play on the idea of a 'colour field' for the goat to roam in, or of the 'ground' on which it

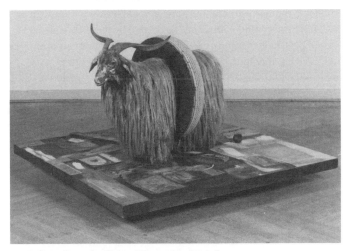

12. **Robert Rauschenberg, *Monogram* (1959).**

could 'figure'. As art historian Leo Steinberg first saw, it also marked a shift from the concept of a painting as an optical, disembodied surface or screen to that of a painting as a 'flatbed' (as he called it, borrowing a term from the printing trade) on which things lay or fell or were placed; a bulletin board, of sorts. This is not to say that painting, for Rauschenberg or anyone else, would now be horizontal (although I shall return to the question of this shortly), but that the governing idea of what the surface *stood for* had changed. For Rauschenberg it was now the common ground of images that he collected from a bewildering range of sources. Using transfer printing and other mechanical techniques, he reproduced photos from newspapers (of space explorations, politicians, sports, birds of prey, tourist sites, whatever), line drawings, diagrams – any image that caught his eye – combining them in paintings whose meanings, though sourced in such public discourses, are as elusively private, and as multiple, as those of Johns.

The liberty of assemblage that Tatlin was among the first to declare has been exploited and expressed in other ways as well. For the surrealists, if the combination of objects or materials no longer entailed a representational purpose, it could have a psychological one. Taking as a model an image suggested by the 19th-century French poet Lautréamont, of 'the chance encounter of an umbrella and a sewing-machine on a dissection table', whose utter unlikelihood fascinated them, they sought what they called a 'convulsive beauty' – that psychic shiver we experience when an image taps into the unconscious, and the hairs stand up on the back of one's neck – through the juxtaposition of disparate things. While the most notorious of these 'surrealist objects', Meret Oppenheim's fur-covered teacup and saucer, and Salvador Dali's lobster telephone, are now perhaps too familiar to us, for a generation of viewers they succeeded in provoking just such a shiver. Other artists have selected materials for their perishability or expendability rather than their psychological charge. Allen Kaprow's assemblages made of refuse, a means of forcing their viewers up against 'the eternal problems of what may be (or become) art and what may

not', as he put it, were among the first in what has become a rich vein of work that in different ways has engaged repeatedly with this question, and with those following from it concerning consumerism's waste and wastefulness: Robert Morris's 'scatter pieces' made of scrap metal or textiles; Tony Cragg's meticulous arrangements of items of plastic domestic rubbish into maps of Britain (*Britain Seen from the North*, 1981) or the colour spectrum; Tomoko Takahashi's recycling of discarded electrical or electronic equipment from skips or car boot sales into roomfuls of winking, buzzing, and flashing piles of junk (Figure 21) – the list could go on. Yet there has been a change as this lineage has unfolded. The assemblages that began in Tatlin's work as discrete objects and continued as such into Rauschenberg's, although made of many materials, have in Takahashi's become 'installations', and this is now common sculptural practice: an entire room, or a created environment within it, or even the entire gallery, can surround the viewer as art. The implications of this for the viewer's relationship to the art are, if subtle, nonetheless fundamental.

Artworks and other objects

When critic Harold Rosenberg coined the label 'action painting' for the work of Pollock, de Kooning, and a few others around 1950, he was taking considerable poetic licence, because none of these artists saw their paintings simply as records of 'events', nor their canvases merely as 'arenas in which to act', as he suggested they did. Yet the term seized on something important: that *temporal* dimension of a Pollock 'drip' painting, the manner and timespan of its making, which also shaped what it stood for – the physicality of his gestures, the atavism of puddling paint onto the floor. When the emotional charge of these attributes of his art had dwindled into New York School cliché, they were looked at anew by younger artists. In 1961 Robert Morris roughly sawed and nailed together a wooden box, about 50 centimetres cubed, into which he secreted a tape-player playing a recording of the sounds he had made in doing so; he called it *Box with the Sound of its Own Making*. Beneath the witty,

Duchamp-like conceit of this lay a perception of the tension between the 'making' and the 'made' of Pollock's paintings, a concern to test, even to question, the borderline between the assumed 'timelessness' of a piece of art and our lived experience of objects, that Morris shared with other artists of his generation.

Simplifying a little, it could be said that this concern with 'objecthood' generated what became labelled (once again by critics) 'minimalism'. Informed by a Duchampian questioning of the status of art which was perhaps provoked by that mid-century institutionalization of modernism and the avant-garde I discussed in Chapter 1, artists across the world played inventively with the threshold of the distinction between art and 'objecthood'. Minimalism in the USA, and its offshoot in Britain, were paralleled by '*arte povera*' in Italy and '*mono-ha*' in Japan. Don Judd made, and wrote about others in the USA who made, three-dimensional objects – often out of stock industrial material such as sheet steel, plexiglass, or plywood – whose internal complexities and subdivisions, whatever these may be, were yet not so pronounced as to outweigh the viewer's apprehension of them *as* objects. The term 'sculpture' was avoided, as begging the question of that very status which these objects sought to test; likewise titles were avoided, as smuggling into them associations that were properly extraneous. In Judd's case, this tension between a work's internal complexity and its 'holistic' quality was the point – one not a million miles away, it might be noted, from the formalists' insistence that an artwork 'acknowledge but transcend its own objecthood' – except that Judd's position was the reciprocal of theirs. But for Morris, what mattered was not so much this tension, more the question of *how* a viewer apprehended an object: that is, given the 'objecthood' of a sculpture in a gallery, what was the perceptual-cum-conceptual process by which we see it as such? Perhaps his most succinct positing of this question was an (untitled) work of 1965 in which four cubic mirrored boxes about 60 centimetres high were placed at the corners of an imaginary square (Figure 13). Offering the viewer everything but themselves – vanishing into their reflections – they

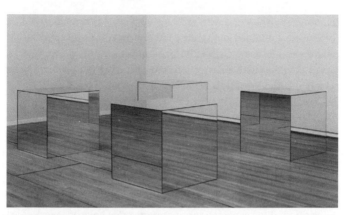

13. Robert Morris, *Untitled* (1965).

were yet unmissable, thus demonstrating how automatically and 'unthinkingly' we decipher the data provided by vision.

Morris's, Judd's, and other minimalists' objects were as big an affront to prevailing ideas of what art should look like as were Pollock's paintings or – more pointedly, since they looked back to these – Tatlin's reliefs, and as revolutionary in their implications, and in their displacement of aesthetic focus from their objecthood they opened the door to an expanded field of sculptural activity. Within months, artists were making art not just *in* the landscape but *out of* it, in works that ranged from the circle made in grass by Richard Long, by picking the heads off daisies, to the gargantuan scale of Robert Smithson's *Spiral Jetty*, made of hundreds of tons of rock in the Salt Lake in Utah. Others were dispensing with objects altogether, following Duchamp's logic of art as idea into 'conceptual art': proposing ideas themselves, independent of visible form, as art. If to 'the person in the street' this was nonsensical, to the formalists it was deadly, and in an essay of 1967, 'Art and Objecthood', critic Michael Fried, leading disciple of Greenberg, took issue with all of it. Minimalism, which he called 'literalism', and its progeny had collapsed the difference between art and theatre, he argued, meaning by 'theatre' not the sort we see on the stage but the spatial

relations we experience with ordinary objects. Art that mattered, on the contrary, enabled us to transcend our awareness of this spatial relation and lose ourselves in its 'presentness' to our vision. He closed the essay with an assertion that offered art as a substitute for religious faith: 'We are all of us literalists most of our lives', he declared; 'presentness is grace'.

Fried's essay has become a landmark of criticism, not only because it posed the opposition between aesthetic principles most lucidly, but also because these principles, despite their opposition, still govern the reception of contemporary art by critics and informal viewers alike. The 'transcendence' he celebrated remains a fair description of the expectations that many of us have of a work of art. Yet the double development, of 'sculpture' into that ever-expanding field of practices that it now comprises (including video and performance, as well as installations, and outdoor and/or site-specific projects), and of the forms and media of popular and consumer culture into spectacle has, it has been suggested, blurred the boundaries between these. The cultural space of artists' installations is perceived by many critics not to be so different from those of theme park features or department store displays or carnival floats, nor that of artists' video from those of MTV or computer games. More than this, the very notion of a 'high' modernist art offering an experience of transcendence of the everyday has come to sound elitist in our would-be democratic culture, and much of the work of the so-called yBas has, in response, been grounded in an aggressive populism: the smutty sexual puns of Sarah Lucas's sculpture, the pop hero masquerades of Gavin Turk, the 'bad girl' behaviour of Tracey Emin. This is work which, to quote the title of Julian Stallabrass's critique of it, has a distinct flavour of 'high art lite' – and which has been successfully marketed as such, chiefly by its principal advertising-tycoon patron.

Yet this apparent dismantling of cultural hierarchies, while it has sanctioned that rapid expansion of sculptural practice into so limitless a field of media that the very term 'sculpture' now seems

redundant, is not the whole story, nor is 'postmodernism', the now ubiquitous shorthand label for it, as all-conquering as its proponents suggest. The recent increase in the number, prominence, and popularity of art musems which I noted earlier indicates something more complex than the straightforward 'consumerizing' of art, for their significance *as institutions* has grown to a corresponding degree. To put it simply, art museums have always been places where certain cultural artefacts or practices have been consecrated as special, and they continue to be. Indeed, the institutional authority of art museums has now established them, rather than the idea of an individual artist's 'genius', as the primary determinant of 'arthood'. Whereas, nearly a hundred years ago, Duchamp believed that his decision alone, as artist, was what established his bottlerack as a work of art, we now know instead thats it's the discourse of modern art, and its main motor the art museum, that does so. This, for any artist still committed, like Benjamin Buchloh as I noted in Chapter 1, to that avant-gardist role of freedom fighter against the culture industry, is the limitation that always accompanies the liberation from the constraints of oil-paint, bronze, and marble that this chapter has traced. Whatever materials an artist uses, however much he or she seeks to integrate art with modern social life through the use of new and non-art technologies, the result depends on art's institutions for its meanings. Not for nothing did the first Turner Prize of this century go to Martin Creed, for the conceit of a work that consisted of switching the gallery lights on and off. What, then, does this now overwhelming authority of the museum imply for the role of the artist? What price individualism, not to speak of genius?

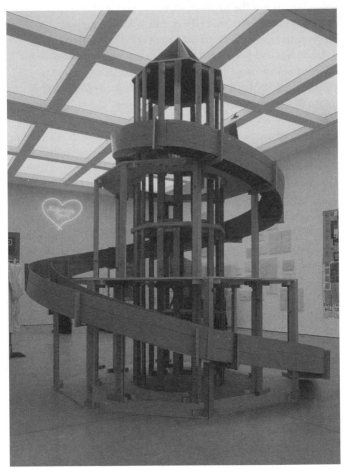

IV. Tracy Emin, *Self-Portrait* (2001).

Chapter 3
From Picasso to pop idols: the eminence of the artist

'Genius' is a concept that now seems rather old-fashioned; it has dropped out of usage somewhat, and even my use of it here is prefaced with this note of apology. It appears to have been superseded by that of 'celebrity', which seems correspondingly impossible to avoid. But is there any relation between the two? A visitor from Mars might be forgiven for assuming so; that David and Victoria Beckham, say, are among the most famous people on the planet because they are extraordinarily gifted. But we know better; we know that celebrity is no such guarantee of great ability but is rather a product of our media-saturated society, our thirst for new heroes and that of the market for new brands. What's more, the very notion of celebrity incorporates an understanding of it as – at least in part – fabricated, phoney, undeserved; while the notion of genius, especially artistic genius, seems entirely different. This speaks, rather, of something genuine, authentic, even unrecognized: thus the popularity of Van Gogh, the epitome of the lonely genius, who sold only one painting in his lifetime, and who shot himself. The myth of Van Gogh is such an enduring one because it *is* a myth; that is, a story of a kind that we need, because it reassures us both of the truth of art, its authenticity, and of our humanity, in that we can recognize this truth even if Van Gogh's own contemporaries did not. What, then, of the present celebrity of some contemporary artists – such as Tracey Emin, whose name has acquired a recognizability unprecedented in the history of British art, thanks

to the media? There is much, after all, in Emin's public persona
that resembles that of Van Gogh: the importance for both of
autobiography, of suffering and violence, the awkwardness of
expression, the outrageous behaviour (Van Gogh's recurrent
epilepsy, his self-mutilation, a 'childlike' style of painting, his
apparent suicide; Emin's abused childhood, teenage rape,
'in-your-face' art, and drunken TV appearances). Yet there have
been very few critics to have had a good word to say about Emin's
art, let alone to declare her a genius; indeed, it would seem to most
of them naïve and old-fashioned to bestow this accolade on the
author of *My Bed*: 'charlatan' would come more readily to mind. Are
we then about to repeat the mistake of Van Gogh's first audiences; is
this a hasty judgement on Emin? Why *is* she a celebrity, if that
status is at such odds with critical (and public) estimation of her
and her art? Why have artists become such unprecedented
celebrities in recent years, and what does this say about the status of
the artist in our society?

Somebody had to be Picasso

The search for answers to these questions takes us back, as a
starting point, to my observations in the Introduction: that over the
course of the 19th century, as commercial values came steadily to
encroach over most areas of social life in the societies of the West,
artistic creativity came in turn to stand for higher values. It might
be added that as reason and organizational logic – what the
sociologist Weber called 'instrumental rationality' – came to play an
increasing role in the pursuit of those commercial ends, that
creativity came, in compensation, to be valued less in terms of
technical skill than in terms of imagination. The Romantic
movement that found representation across all the arts in Europe in
the first third of the 19th century was the first embodiment of this,
and its hallmark attribute 'genius', a term that had previously
signified the mastery of technical skill, acquired the connotation of
extraordinary access to, and intuitive articulation of, the faculty of
imagination. It is worth noting too – for it is a point I shall return

to – that as Christine Battersby has shown, in the process of this shift of meaning 'genius' acquired the very qualities that had previously been disdained as 'feminine', in contrast to the 'masculine' values of reason and technical skill. Men could continue to present themselves as more profoundly creative than women: in touch *as men* with their 'feminine' side, whereas women were simply slaves to their irrational natures.

With the consolidation of the market for modern art around the turn of the 20th century, and the emergence of the avant-garde as both a cultural formation and a collective identity for un- or anti-academic artists across the cities of the West, the notion of 'genius' gained a strategic role: from being an occasional accolade for supremely (imaginatively) gifted individual artists, it developed into the guarantor of the authority of that avant-garde. Just as it was impossible to imagine an academic artist of genius – so compromised by careerism, dulled by instruction, and limited by protocol would he (and occasionally she) be, by definition – so it was equally by definition that the term encapsulated, to the highest degree, the qualities of free-thinking independence and originality for which the avant-garde saw itself as standing. It was a faith in genius that underwrote the dealer Durand-Ruel's gamble in buying the entire contents of painter Theodore Rousseau's studio in 1866. It was a 'nose' for genius (and the self-esteem that came with the awareness of having one) that led the discerning collectors of the pre-First World War decade to put their money on young unknowns. And it was the recognition that genius was a quality 'in the gift' of the market – a *constructed* position and disposition – that governed the dealer Kahnweiler's championing of Picasso's cubist excesses.

In short, there was a space already created by the cultural aspirations of late 19th-century societies, by the ideology of avant-gardism, and by the dynamics of the modern art market for the concept of 'genius', a place for it as the keystone of the modernist arch. That Picasso should occupy it, as the presiding genius of his

age, was thus not simply a consequence of his possessing unique gifts (although it was important that it should appear to be), but because his particular abilities and ambitions were what were needed then and there, in early 20th-century Paris. His precocious graphic virtuosity, his determination to avoid the easy solutions this afforded him in preference for the expressive rewards of re-inventing a pictorial language from scratch, his personal charisma and sexuality, inventive and mischievous wit, and avant-gardist ambition – the combination of these qualities pre-ordained him as the very type of artist-genius for the new century. He was not, as it happened, the *proto*type: this had been the sculptor Rodin, whose unorthodox art training, stylistic and technical innovations, and notorious studio habits made him a model for the avant-garde artist a generation before Picasso's arrival. Rodin had failed the entrance examination for the national Fine Art School three times before being eventually apprenticed to a sculptor of monuments; he distorted human anatomy wildly in his expressive modelling in clay, and introduced the conceit of the incomplete torso; and he required his female models to walk naked around the studio as he captured both those poses he liked and the lascivious imagination of the public. But Picasso was a painter *and* a sculptor, had a more developed art market at hand, and – perhaps crucially – an appetite for contemporary forms of expression, especially the low humour and disposable wit of commercial culture: music-hall, comics, popular songs, penny newspapers. Such factors gave him far greater expressive and material resources than Rodin enjoyed. By 1914, before his mid-30s, Picasso had established the character of his genius: an amalgam of alchemist, Shakespearean Fool, and satyr that placed his creative imagination at the centre of his art for all but four years of his career, and endowed it with an emotional reach that went from high tragedy to low slapstick.

Those four years were the period in which, with Georges Braque, he fashioned the deep structure and radical vocabulary of a style of painting – christened 'cubism' by its critics – whose potential for

generating new anatomies and new meanings gave it the status of a model for modernism that I have earlier noted. 'Braque was my wife', Picasso famously recalled in later life of their partnership in cubism; Braque's own preferred metaphor was that of 'two climbers roped together on a mountain'. Between them these images summarize pithily the combination of sexism, adventure, and machismo that characterized the first-generation avant-gardes – whose progressive, modernist interrogation of prevailing artistic convention was unfortunately routinely accompanied by a regression to pre-modern sexual relations. As Carol Duncan noted 30 years ago, the work of these avant-gardes 'defines a new artist type: the earthy but poetic male, whose life is organised around his instinctual needs', and whose art 'depicts and glorifies what is unique in the life of the artist – his studio, his vanguard friends, his special perceptions of nature, the streets he walked, the cafés he frequented'. In this culture, and this vanguard endeavour, women were not included as equals; with very few exceptions, the roles they could occupy were limited to those of mistress, muse, or manager of their partner's career. Indeed, as the discourse of modern art was elaborated over most of the 20th century, the exclusion went deeper than behaviour alone. While this self-conscious bohemianism slowly gave way to more 'bourgeois' habits as the avant-garde formations became settled and normalized, its masculinism found expression in the aesthetic principles on which most modernist art came to be built. These principles were defined – by artists, critics, and historians – not only as positive qualities but also against alternatives, in what cultural historian Peter Wollen calls 'a cascade of antinomies'. Thus modernism can be seen, as he suggests, to have privileged the constructive over the decorative (thus, the linear geometries of Picasso's cubism over the sensuousness of Matisse's colour); the machine as against the body ('the house is a machine for living in', modernist architect Le Corbusier once famously declared); economy over excess; West as against East – in a set of oppositions (others could be added) underpinning which was that of 'masculine' as against 'feminine'. As a result, not only was art

by women modernists assumed to be secondary unless (and sometimes even when) it displayed these preferred qualities, but it was at times by definition invisible. Thus, among many others, Sonia Delaunay, a pioneer in the fields of abstract painting, fashion, and graphic design from 1910 to 1970, and Lee Krasner, a painter at the forefront of mid-20th-century New York abstraction, were both until recently sidelined as imitators of Robert Delaunay and Jackson Pollock, their respective husbands. And, to take another example, the desire whose liberation surrealism sought was *male* desire; as such, it was hardly possible that there could be women surrealists of any importance. This is how it was understood by generations of art historians until recent feminist scholarship demonstrated that, on the contrary, the work of Leonora Carrington, Frida Kahlo, Dorothea Tanning, Eileen Agar, Claude Cahun, and others was fundamental for surrealism's significance. Similarly (and to date more enduringly), the art of the New York School of the mid-20th century has been coloured indelibly as masculine, the emphatic physicality of gesture that characterized much of it decisively underwritten as such by the 'hard drinking and hard living' persona that was constructed for Pollock, above all. Tom Wolfe's account (in *The Painted Word*, his 1975 lampoon of the postwar art world) of a drunken and naked Pollock urinating in the fireplace at a collector's party in his honour may be apocryphal, but it became emblematic of a potent myth of the New York mid-century avant-gardist as macho outsider. Yet there were women artists in the Abstract Expressionist movement, not all of them (like Lee Krasner and Elaine de Kooning) married to its luminaries. One of them, Hedda Sterne, even made it into a photograph published in *Life* magazine in 1951 of the 'Irascible Group of Advanced Artists' (as its caption put it), the only woman in a group including all of the movement's major figures – and the only one who even now remains an unfamiliar name.

Women artists: making a difference

For individual women artists who were faced with a modernism that was defined in terms of 'masculine' qualities, by an avant-garde whose behaviour and protocols denied them the space from which to challenge this, there were few alternatives to invisibility. One was masquerade: the performance of a 'femininity' that accepted and heightened their difference, but at the cost of surrendering the chance of equality on modernist terms. From the late 19th century, critics had been encountering an upsurge in numbers of women artists that was one expression of the feminism of that time. They met it by constructing a category of 'feminine art' whose hallmarks were – of course – sentimentality, domesticity, and charm. Marie Laurencin was the first woman from within the avant-garde formation to make the occupation of this space into a career strategy. From around 1908 she made paintings in pastel pinks, blues, greens, and greys whose languid forms and domestic or poetic-fantasy subjects exaggerated the qualities of 'feminine art' almost to the point of parody, and accompanied them with an equally exaggerated feminine persona. 'If I did not become a cubist painter', she wrote in later life, 'it is because I never could. I was not capable of it – but I am passionate about their researches'; and more generally, she declared,

> If I feel so far removed from painters it is because they are men . . . Their discussions, their researches, their genius have always astonished me . . . the genius of men intimidates me.

Whereas she felt, as she wrote in her memoirs,

> perfectly at ease with everything feminine . . . When I was little I used to love silk threads, I used to steal pearls and coloured cottonreels; I would hide them and look at them when I was alone. I always wanted to have lots of children so that I could comb their hair and put ribbons in it.

The strategy of masquerade worked, after a fashion: critics responded to such simpering with a corresponding gallantry, and Laurencin has come to occupy a distinctive place in histories of the 'École de Paris' of the inter-war period. In recent years, postmodern art historians have begun to wonder if the parody was intentional, and to read Laurencin's art as laced with irony; but if this is so, it is very subtle indeed.

Yet even for women whose aspirations and aesthetic orientation were identical to those of their male contemporaries, the categorization of 'feminine art' – the assumption that their art *performed* their femininity, directly and necessarily – was hard to escape. The American painter Georgia O'Keeffe shared with many artists of her formative years in the 1910s a concern to explore the borderline between figuration and abstraction, that zone of pictorial ambiguity where lines, shapes, and colours hovered between the suggestion of embodied forms and the declaration of their own artifice. For many, including artists as different as Duchamp, Léger, Kandinsky, and Mondrian, this was understandably a first step in a move away from representation that was, for a time, an obligatory undertaking for any self-respecting modernist. Only O'Keeffe's art was read, by everyone, in gendered terms. A painter friend saw in it her 'utterly embedded femininity'; a critic wrote of it 'rendering in her picture of things her body's subconscious knowledge of itself'. When O'Keeffe, seeking a means of evading such masculinist cliché which was 'so strange and far removed from what I feel of myself', turned to real, identifiable flowers as the basis for her pictorial explorations, and played the luscious colours and curves of cana and calla lilies against the self-referentiality of flat washes of paint and subtle contradictions of shape and space – a strategy that has been called 'abstraction in masquerade' – the response was even more sexist. Critics constructed from such pictures a reputation for O'Keeffe that still dominates the reception of her art, as the 'feminine' artist *par excellence*: the painter of flowers that represent the vagina. Yet there was no such inference of an utterly embedded *masculinity* when

Marcel Duchamp in 1912 painted *Bride* and *Passage from Virgin to Bride*, pictures whose ambiguously visceral forms have distinctly gynaecological associations. Delivered deadpan, his sexual innuendo was read as knowingly ironic rather than driven by deep desires.

Equally deadpan was Duchamp's playing with masquerade. In a move that was typical both of his impish wit and of the strategic intelligence of the chess-player that he was, in 1920 Duchamp created an alias for himself whom he named Rrose Sélavy. Pronounced '*éros c'est la vie*' [eros that's life], this alias served, through its attachment to the titles of a variety of *Readymades*, as a vehicle for the fascination with sexuality, its charge and its frustrations, that ran through his work. But it also punctured the masculinist pretensions of modernism, delivering a sly but telling kick to the crotch of that 'earthy and poetic male' of the standard avant-gardist self-image. Turning himself into a *Readymade* Duchamp was photographed as Rrose several times by Man Ray in 1921, in one photo dressed in a fur-collared coat and cloche hat with jewellery and make-up, and with an expression that some have likened to that of the Mona Lisa – whose enduring sexual allure he had also subverted two years earlier, in a *Readymade* in which he added a pencilled moustache and beard to a reproduction of her, and the caption *L.H.O.O.Q.* (the French pronunciation of which sounds like '*elle a chaud au cul*' [she's got a hot arse]). But Rrose is also, in these photographs, distinctly fashionable, and Duchamp's cross-dressing subversion of femininity said as much about contemporary sexualities as about art history.

And it still does: Rrose continues to have a shadowy presence behind the masquerades constructed by the American artist Cindy Sherman since the late 1970s. Sherman's earliest work consisted of supposed 'untitled film stills', black-and-white photographs of young women seen in a variety of situations: a blonde dressed sexily in sweater and skirt perched on a window-sill and gazing at the scene outside and below (Figure 14); a half-figure view of a smartly

14. Cindy Sherman, *Untitled Film Still #15* (1978).

dressed woman in a city street looking with apparent anxiety out of the shot; a hitch-hiker with suitcase by a roadside. All have the look of stills from films that are familiar but not quite placeable, and the figure in all of them is Sherman herself. We know this, and yet the women are so different from each other in appearance, dress, and demeanour that it is hard to believe – and it is the tension between that knowledge and this changeable appearance that reveals the *constructed* nature of female identities and

femininities in modern society. Looking for the 'real' Cindy Sherman beneath the masquerade is a futile pursuit which nevertheless places clearly in quotation marks the artifice of the various identities she adopts, and in their resemblance to key images from the films of, say, Hitchcock or Doris Day her photo works show up both the devices and the assumptions with which that artifice has been built.

Sherman's subsequent work continued to explore these issues inventively, engaging with art history in a series of wicked parodies of 'old master' pictures, and with the disturbing 'otherness' of masquerade in a more recent series of clown figures. Those early photographs, however, were charged with the force, unequalled since, of a revitalized women's movement of whose frontal attack on sexism in all its forms they were a part. That is, it was because of their articulation *with* that movement in the 1970s, as well as *of* its widely shared sense of injustice, that these images – like those made by a growing number of women during and since that decade – had and still have such resonance. Equally telling are the photomontages with which another American artist, Barbara Kruger, has since 1980 explored the social construction of femininity. A former art editor at Condé Nast Publications, Kruger has employed the formats of its magazine layouts: declarative slogans, urgent red-banner typefaces, and glossy black-and-white photos, to up-end the very values on which their selling of female sexuality is premised. Again, the force of this work draws on the discourse of women's liberation as much as it enriches and disseminates this.

Such art helped to advance the cause of feminism through its critical representation of the many ways in which women have been forced to accommodate their sense of self to the demands of a society dominated by men. What's more, the momentum and breadth of this movement has, in its turn, brought about a fundamental revision both of the image of the artist, and of the cultural spaces within which he or she now functions. This revision

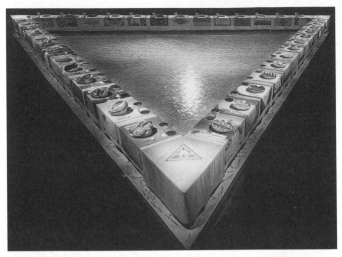

15. Judy Chicago, *The Dinner Party* (1979).

has taken three principal forms. First, feminism has compelled a recognition of the work of women artists of the past, which has enriched the inheritance of contemporary artists and offered new models and inspiration for women among them. One of its first landmarks was a sculpture, *The Dinner Party* (Figure 15), produced collaboratively (as a gesture towards a tradition of women's cultural practice, and towards an alternative to a perceived masculinist individualism) but under the direction of artist Judy Chicago, between 1974 and 1979, which consisted of a triangular arrangement of dining tables with 39 place settings; each setting named a woman artist or writer of the past (O'Keeffe was the sole living artist included; other figures included the poet Emily Dickinson and the novelist Virginia Woolf) and symbolized her by a ceramic plateful of vagina-shaped forms.

It was followed by other work of recuperation in a range of media and registers, including in 1981 an art history book, *Old Mistresses* by Roszika Parker and Griselda Pollock, and the following year an exhibition in London's Whitechapel Gallery of the work of painter

Frida Kahlo and photographer Tina Modotti, curated by Laura
Mulvey and Peter Wollen. The Whitechapel exhibition brought to
unprecedented and deserved prominence, for art audiences in the
West (the show travelled to Germany, Sweden, the USA, and
Mexico), the highly individual work of two women: both part-
Mexican and centrally involved in the post-revolutionary
flourishing, in the 1920s and 1930s, of the Mexican avant-garde;
both (like so many major women artists of the last century)
previously overshadowed by a more famous husband. In Kahlo's
case this was the Mexican muralist Diego Rivera; in Modotti's, the
American photographer Edward Weston. Since the exhibition,
Kahlo's paintings in particular have been the objects of growing
veneration, through further exhibitions, books, posters, and films –
but this is for reasons that highlight the problems involved in such
recuperation of female artists for a canon whose premises are
otherwise undisturbed. She had died in 1954 in her early 40s, and
could thus be monumentalized in a way that a living artist could
not; she had died as a long-term result of horrific injuries, sustained
25 years earlier in a traffic accident, the catastrophic consequences
of which for her self-identity as a woman she explored obsessively in
her paintings. These paintings were intimate and privately
symbolic, yet they also immediately and unmistakeably address
themes that others can share: her identity as a woman, and also as a
Mexican; bodies, birth, and death; popular and high culture; her
relationship with a forceful and unfaithful man. As a result, Kahlo
has become not only a cult figure, but one whose grounding in the
combination of personal suffering and gender victimization has, it
can be argued, functioned not to disturb a modernist canon
established on the image of the suffering, heroic artist, but to
reinforce it. As much as her experiences and the way she painted
them hold out an alternative to a masculinist modernism, they are
also the features that entitle her to join its heroes – and have
enabled the institutions and protocols of an art world made to
safeguard male greatness to annex her work without discomposure.

It was this problem, and the associated 'essentializing' of the art of

women as necessarily, even unconsciously, indexing their gender, that made *The Dinner Party* a controversial work among feminists: its insistence upon the relation between the art and the sex of the women it championed appeared, to many, to tie *all* women's art into the same biological imperative that had imprisoned O'Keeffe. Yet in its celebration of the bodily dimension of 'womanhood' it was typical of an approach to art-making that grew, as the decade unfolded, into a second kind of challenge to contemporary art-making by men. For in contrast both to the hermetic abstraction of formalism and to the theoretical dryness of minimal and conceptual art, many women artists sought to ground their aesthetics in an affirmation of their bodily identity and difference, others in an acknowledgement rather than a denial of lived experience. These concerns in themselves did not distinguish contemporary art by women – Robert Rauschenberg and Claes Oldenburg were among many male artists who also worked, as the former put it, 'in the gap between art and life' – but the momentum of the women's movement at large (not to speak of its slogan 'the personal is political') gave their engagement with themes of autobiography and embodiment a coherence, at times even a programmatic character, that was influential upon a generation of women artists. Such work also had considerable breadth of register. The sculptures that Eva Hesse made before her death at the age of 34 in 1970 shared minimalism's interest in art's objecthood and in industrial materials, but joined to these a wry and sensual awareness of the bodily connotations and symbolic potential of such mute objects that laced minimalist seriousness with appealingly low, and gendered, humour (Figure 16).

At the other extreme, Mary Kelly's complex *Post-Partum Document* of 1974–9 offered a history of the developing relationship that occurs between a mother and her child that contradicted the dominant representation of this relation as 'natural'. Combining several kinds of documentation – of her child's bodily traces and gestures on various materials, from soiled nappies to pencil scribbles; of his feeding regime; of her diary reflections on her

16. Eva Hesse, *Untitled*, or *Not Yet* (1967).

experience; of theoretical constructions of subjectivity in the writings of Freud and Lacan – in a visual display that contrasted these in what she called a 'scripto-visual' manner, Kelly's work was ground-breaking both in its subject matter and in its theoretical sophistication.

Celebrating the past achievements of women and emphasizing both the social construction of femininity and the bodily dimension of female identity were welcomed, but many felt that these had to go hand-in-hand with challenges to the art world itself. It was in mounting such a challenge on an ideological and historical level that *Old Mistresses* was most useful. In response to Nochlin's question 'Why Have There Been No Great Women Artists?', Parker and Pollock provided a compelling argument that 'greatness' has historically been *defined* as masculine (an argument subsequently developed, as I have shown, by Christine Battersby), and they pointed to the ways in which this had been achieved, through sexist bias in the teaching of art history, in the publication of books on art, and in the curation of exhibitions. Their book gave added momentum to a third way in which feminism challenged art's practices and spaces. This was the drive by women artists, critics, curators, and art historians, in North America and Europe especially, to scale the walls of the citadel of contemporary art, not just to capture but to dismantle it – a collective campaign whose British dimension Parker and Pollock documented and reviewed six years later in another book, *Framing Feminism*. As they noted there, the dichotomy between seeking equal recognition with men and challenging a patriarchal art world:

> . . . reflected a similar division in the Women's Liberation Movement. Should women seek to establish themselves as professionals, or should the trappings of professionalism be rejected in favour of the wholesale recognition as art of whatever women make. On the one hand there was the Women's Workshop of the Artists' Union fighting to revolutionise the conditions of professional work, and on

the other there were those who felt that in order for skills traditionally associated with women to be recognised and valued, hierarchies – professional/amateur, public/private, fine/decorative arts – had to be demolished.

Over the 15 years documented by *Framing Feminism*, women pioneered a range of alternative practices of art-making and exhibiting. *Feministo*, a project of exchanging art through the post, was begun by Kate Walker and Sally Gollop in 1974 as a means of circumventing the difficulties of making art while having young children to raise and no space but the kitchen table to work on. Two years later they had been joined by a dozen others and had made over 200 works on the theme of the artist as housewife and mother. Walker's knitted wall-piece *Art Not Heart/Homemade I'm Afraid* and crocheted 'full English' breakfast plate of bacon and eggs were examples; others included a Black Magic box containing female body fragments made of chocolate, and a plate of salad with a (papier-mâché) reclining female nude in place of the slice of ham. The works were shown in galleries around Britain, including at the Institute of Contemporary Arts (ICA) in London.

Another strategy, and type of art, was performance. Often a more immediate means of artistic communication, performance art drew on popular culture traditions as well as that of avant-garde movements such as Dada, futurism, and the 'Happenings' of New York artists, and could, as in New York-based Carolee Schneemann's performances, use the body as a symbol and a resource – 'a stripped-down, undecorated human object', as she put it. Or, like Susan Hiller's *Street Ceremonies* and *Dream Mapping* works of 1973–4 in London, it could engage large numbers of spectators in participatory events. Through the next decade performance grew so rapidly in scope and in the number of feminist artists performing that Parker and Pollock noted in 1987: 'today it would be the rare feminist art show which did not include a performance section'. Also, exhibitions were held in non-art venues: in libraries, disused factories or warehouses, children's nurseries,

derelict houses; initially used from necessity, such spaces were increasingly sought out as a means of avoiding the institutional associations of galleries. But it became clear that such alternative venues risked marginalization, and protests were staged against the exclusion of women from major art survey shows, in New York at the 1970 Whitney Annual, and subsequently in Los Angeles, Washington, and the Hayward Annual in London. At the same time all-women galleries such as AIR in New York afforded some redress of the gender imbalance of such surveys. By 1980 these strategies had begun to reap rewards: that autumn the ICA held three consecutive major all-women, overtly feminist exhibitions.

It is clear from the vantage point of the present, however, that by the time that *Framing Feminism* appeared, the women's art movement, like militant feminism at large, had passed the peak of its momentum. While this anthology of the textual (and mostly ephemeral) residues of its campaigns demonstrated its richness and diversity, the fact that it was published at that moment suggests a need to take stock at a time when the neo-liberal politics of an ascendant Thatcherism in Britain and Reaganism in the USA were turning the cultural tide, and there is a note of fond farewell in its introductory surveys, alongside the underlining of the movement's gains. These gains were real and lasting: it is now impossible to conceive of contemporary art practice without the substantial presence of women, and the art schools of the Western world are producing female and male graduates in equal numbers. The macho male outsider in the Pollock mode is now as obsolete a model for the modern artist as the alchemist-fool-satyr genius that was Picasso, thanks largely to the challenge of feminism.

Moreover, its example has opened the way for other under-represented groups to challenge the white/Western model of the artist. In ways that we shall explore later, postcolonialism and the politics of sexuality have contributed to present and continuing realignments in the image and practices of modern art. But obstacles to such progress remain, and feminism has met some

setbacks. In the art world, as in society at large, power structures and relations remain much as before: male dealers call the shots in the market; most art prizes still go to men; women remain in a minority in top curatorial positions, as in the public and private sectors of the economy as a whole. Feminist art has been assimilated, often through the agency of sympathetic curators, but into a museum culture that instantly deradicalizes its sexual politics and re-stages this as spectacle (the sculptures by Louise Bourgeois with which Tate Modern inaugurated its Turbine Hall exhibitions programme in 2000 were a case in point). A younger generation of women artists take the achievements of their counterparts of the 1970s as much for granted as self-styled 'post-feminist' young women do in general.

Which returns us to Tracey Emin. For this is one dimension of the context within which we must place her work if we are to answer the questions I posed at the start of this chapter. Emin and other female members of the 'yBa' stable, Sarah Lucas most prominent among them, have acquired a reputation as 'ladettes' in current parlance: their brash, sexually explicit art and immoderate public behaviour are taken as equivalent, in a way that was not previously open to young women, to the pushy vulgarity more commonly associated with young, mostly working-class men; Lucas's 'self-portrait', *Two Fried Eggs and a Kebab*, which features these objects so arranged on a plain table as to suggest her breasts and genitals, mocking the reclining nude of high art with the crudeness of toilet graffiti, is representative. But Emin's work, while sharing some of these qualities, also makes implicit reference to feminist precedents, as well as other avant-gardist ones. Her quilted, embroidered, and appliquéd blankets with their angry, desperate confessional declarations look back to the tradition of women's craft activities, and to the example of Frida Kahlo's autobiographical, populist symbolism and style. Such works affectingly, but also knowingly, re-stage Kahlo's manner and her suffering persona in the contemporary idiom of street and fashion-magazine graphics or political murals. In another register, her now notorious tent with appliquéd lettering,

Everyone I Have Ever Slept With, 1963–1995 (1995), now equally notoriously destroyed by fire, played with the viewer's assumptions of her promiscuity in her inclusion of the names of two aborted foetuses, her twin baby brother, and other family members in its roster of sleeping partners. Knowing that 'we' would read it as a declaration of her sexual prowess, Emin suggested with these inclusions that the work has, in truth, more to do with the intimacy of shared sleep than that of shared sex. The irony of this does not centre only on confounding clichéd and sexist assumptions about loose women, however. It also plays with her own celebrity status, and with the persona of 'bad girl' that she has been complicit with the media in constructing for herself. Emin addresses this theme of artist-as-celebrity with a reflexiveness and premeditation for which she is rarely credited, drawing – as in her acknowledgement of feminism – on previous instances of it as a resource, weaving her reprisal of these into the ambiguities of her own work.

Pop idols

The phenomenon of 'celebrity' is a product of the mass media. In addition to the name recognition that is the criterion of 'fame', it implies a mediated closeness to an audience, the illusion of which is dependent upon the ubiquity of the reach of images of the famous into our daily social environment. While there have been celebrities for as long as there has been a press with such a reach – which means at least since the mid-19th century (when, incidentally, the term was coined) – it is the postwar saturation of social life achieved by a proliferating mass media, led by television, that has given 'celebrity' the meaning and lustre that it has today. It is therefore no coincidence that artists first became celebrities in the contemporary sense in the mid-20th-century USA. Jackson Pollock was the prototype: while his career peaked before modern media saturation was achieved, he was the first modern artist to be given wide publicity in the popular press even before his avant-garde reputation had been secured. It was primarily *Life* magazine that turned Pollock into a household name; pursuing a policy of closing

what it called 'the chasm between artists and democratic society'. In October 1948 it published an illustrated account of a 'Round Table on Modern Art' it had organized at the Museum of Modern Art in New York, in which Pollock took star billing as representative of that art's most extreme tendencies. A year later *Life* devoted a photo-spread article to him entitled 'Jackson Pollock: Is he the greatest living painter in the United States?'. Far from containing the 'knocking copy' that conventionally lampoons avant-garde art in the popular press, these articles were respectful, even sympathetic, and in thus singling him out for serious attention they gave his name a currency and a cachet in the media that were soon capitalized on by others; Cecil Beaton's 1950 *Vogue* photo-shoot, which I've already mentioned, clearly depended heavily on both.

Pollock's celebrity was both unsought (though not, it appears, regretted) by him, and entirely external to his art practice. Andy Warhol's celebrity was the reverse in both respects. Warhol had always sought fame, for the usual reasons that many people do, from the start of his career as a graphic artist, and apparently turned from shoe illustration to painting because of the greater acclaim it seemed to promise. But he had been obsessed with celebrities even from childhood, and his adoption of celebrity itself as a central theme of his art was in keeping with this overheated fascination. It was not only a matter of choosing celebrities as subjects, as in the *Marilyn*, *Liz*, and *Jackie* silkscreens that marked his rise to fame in the mid-1960s, but of playing with the mechanisms and trappings of celebrity status as well. He parodied the Hollywood studio system by developing his own group of 'stars' from his circle of friends and upping the ante by designating them 'superstars' – only these, as cultural historian John Walker noted, were a motley bunch of social misfits who, unlike stars under contract in Hollywood, were 'unpaid, untrained, undirected and eventually unemployed'. He screened the films they appeared in at mixed-media events, and recruited a rock band, the Velvet Underground, to play at these; the band's own subsequent fame fed into Warhol's reputation as a 'supercelebrity', not only someone

celebrated in his own right but a manipulator of celebrity itself as if it were an art material. The manipulation was conducted in several dimensions. Continuing his fascination with stardom, he turned his social life into an art practice, documenting with camera and tape recorder his every phone call and conversation, founding a magazine, *Interview*, in 1969 as a vehicle for glamorous photos of film stars and other celebrities. His own appearance, like that of the several transvestites and drag queens in his entourage, was an endless masquerade: heavy make-up and an array of wigs (he owned 50 in the 1980s) helped him, as some have noted, to express in his own person 'the close connection between beautification, reinvention, transformation and drag'. Behind these various personae – behind all of his artworks – was, he seemed at pains to imply, not an inner self but a mirror. Yet while this clearly subverted the conventional image of the artist as unique, creative, and original, it did so with an effectiveness that left the public in serious doubt of its strategic character. While the subversion required that the blank, reflective, glamorous façade be always kept in place, there remained little room for a sense of *his* irony, his distance from his image, to gain a foothold. In the end, Warhol's celebrity was less a theme of his art than the real artwork itself; but it is the ambiguity of his investment in it, more than the work, that has continued to intrigue.

Other modern artists have invested in celebrity in different ways. The German artist Joseph Beuys did so by adopting the persona of a 'shaman' – cloaking himself in a quasi-magical aura of mystery that was grounded in a much-recounted account of his having been saved, when shot down over the Crimea as a Luftwaffe pilot in World War Two, by tribesmen who smothered him with animal fat and wrapped him in felt (the two materials featured frequently in his work). The mystery was enhanced by suggestions of a special affinity with animals, as in his 1974 piece *I Like America and America Likes Me*, in which he cohabited with a coyote in a New York gallery for three days, wrapped throughout this time in a felt blanket. The British artistic duo Gilbert and George cultivated

celebrity from the start of their career through an idiosyncratic persona and behaviour – each initially refusing to be identified either as 'Gilbert' or as 'George' (this pose was later abandoned), and presenting themselves as 'sculptures' rather than 'sculptors' (their early pieces were performance works for which they dressed in identical tweed suits and painted their faces gold). In the 1980s, the celebrity that this reputation for idiosyncrasy acquired for them was consolidated by notoriety gained from a number of high-finish photo-works combining images of urban youths with racist and homophobic graffiti; the 'frisson' of this glossily packaged juxtaposition of tweedy reticence and street violence proved irresistible to the art (and wider) press, and secured for them the art stardom they enjoy today.

Perhaps more than any other contemporary artist, Tracey Emin has come to stand in Warhol's footsteps, occupying the space of artist-celebrity that he carved out for himself, but also developing it in significant respects. Like Warhol, Emin appears to use ambiguity as a strategy. In the consistently autobiographical focus of her art and the intensity of its character, with its unflinching exposure of a painful past; in her combination of graphic work (mostly monoprints) that seems both in style and in subject matter as untutored, scratchy, and crude as toilet graffiti with an equally artless use of the public media of video and photography; in her accompaniment of this work with readiness to model in fashion magazines, to sponsor products, to appear on TV quiz shows – in all of this her work gives a first impression of a self-absorption, clamour for attention, and desire to shock that are naïve and even childish. As such, it seems unmediated, unpremeditated, authentic, yet of questionable quality, as most of the press – art critics and tabloid journalists alike – appear to have concluded. Yet it is also not only 'knowing', as I have suggested, but steeped in self-conscious cultural references. Many of these are to art history: not only to Schiele but also Edvard Munch whose Nordic self-absorption Emin obliquely reprises; to Vladimir Tatlin, whose ambitious and Utopian construction *Monument to the Third*

International of 1920 (Figure 5) she parodied in her 2001 'helter-skelter' piece *Self-Portrait* (Plate IV); to the sexually explicit painting of 19th-century avant-garde patriarch Gustave Courbet; to the conceptual art of the 1970s and 1980s. Others are to popular and commercial culture: to Vivienne Westwood, whose clothes she models and wears – indeed, cultural historian Ulrich Lehmann has suggested that Emin is the Westwood of the art world as Westwood is the Emin of the fashion industry, in that 'both are seen as subjectively irrational, emotionally bare – and therefore very feminine – and each as the sexually liberated "wild child" of their respective generations'. Moreover, in several works Emin shows clearly not only her awareness of her celebrity, but – again reprising Warhol – its role as a 'material': thus *I've Got It All* of 2000, an ink-jet photographic print (a medium with distinctly non-art connotations) of herself seated, dressed in a low-bodiced minidress, legs splayed out either side of the lens, stuffing a huge pile of banknotes and coins into her apparently knickerless crotch. Image and title interact here punningly to lay bare the sexual and pecuniary implications of this self-portrait of the well-endowed artist.

Thus Emin's work both is and is not what it appears at first sight to be. It *is* all those things 'we' see on first impression, but it is *also* the reputation that inescapably accompanies each exhibition of it, brought by its audiences, as well as the mechanisms – above all, of 'celebrity' – by which that reputation is produced and sustained. Her complicity with these mechanisms, and with the media industry that drives them, can perhaps be likened to that of a lion tamer putting his (or her) head in the mouth of a circus lion. Both are dangerous tricks to perform, if in each case necessary if the audience is going to keep its eyes on the act. If the one risks losing his (or her) head, the other risks losing the critical independence, that purchase on alternative circuits of meaning to that of the dominant, which has been the life-blood of modern art. The question is, how hungry is the lion? How voracious is the media industry? What have the audience paid to see?

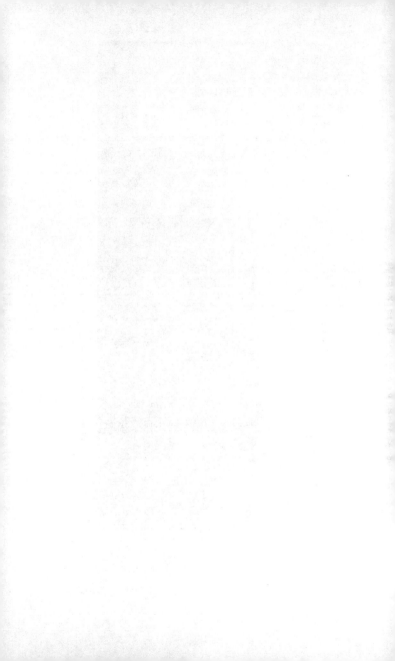

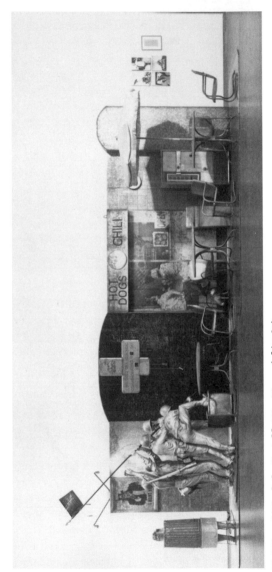

V. Edward Kienholz, *Portable War Memorial* (1968).

Chapter 4
Alchemical practices: modern art and consumerism

The circus was a favoured subject among avant-gardist artists around the turn of the last century. Seurat painted it, as did Picasso, Chagall, the devout Christian painter Georges Rouault, and many others. They did so partly because in its multinational community of marginalized, bohemian, and nomadic risk-taking performers they saw an (perhaps flattering, certainly romanticized) image of themselves, and partly just because they enjoyed it. A hundred years ago, going to the circus was a common popular pastime. Most big cities had permanent circus arenas, and one of those in Paris – the Médrano – was conveniently just down the hill from Montmartre's studio ghetto. But it was only one of many forms of popular entertainment, and in the decade before 1914 it was rapidly being superseded by more modern ones: cinema in particular (Paris had five cinemas in 1900 and nearly 300 in 1914, by which time London and New York each had over 400), but also cabarets and music-halls, 'penny' newspapers with their stranger-than-fiction human interest stories and their comics, and street advertising. Moreover, the decade that saw the first flourishing of the avant-garde formations of Europe and the USA also saw that of consumerism, as well as commercialized entertainment. Department stores mushroomed, selling new consumer durables such as sewing machines,

telephones, electric lamps – domestic and leisure appliances that were promoted in the advertising that made the penny press possible, and whose billboards were changing the face of every city. For any self-styled modern artist, the burgeoning new graphic environment that these developments created was an irresistible theme.

There are parallels here with our own time. The proliferation of new media of communication – but also entertainment – consequent on the invention of the microchip is overturning markets and patterns of social behaviour alike, and the global spread of consumer culture in general seems inexorable; similarly, fascination with this culture, and especially with the allure of kitsch, seems to have become the dominant theme of artistic expression. From Jeff Koons' ceramic statuettes of Michael Jackson, through the Royal Academy's 'Sensation' exhibition of 1997, to Matthew Barney's extraordinary plundering of the American pop-cultural imagination in his epic multimedia *Cremaster Cycle* (1994–2002), kitsch seems to be everywhere in contemporary art, almost obligatory for any aspiration to 'relevance'. And this apparent similarity of orientation has opened fresh perspectives on the art of that earlier epoch, inviting today's audiences to an enjoyable complicity with its engagement with 'low' culture – a complicity that had previously been frowned upon by the influential critic Clement Greenberg in his insistence on the superiority of an unadulterated 'high' art tradition. This invitation is liberating, but we need to beware of it. One of the essential lessons, as well as the pleasures, of the study of history is that the past is always changing – its profile shifts and new features are thrown into relief as the light of each different present catches it. But in these changes, other features are cast into the shade. So we must be careful to distinguish between the fascination with popular commercial culture of that avant-garde a hundred years ago, and our apparently similar fascination at the present time, and we must pay attention to those aspects of the former that are beyond our spotlight. Primary among these in the first decade of

the 20th century was a commitment to the modernist 'project' – that is, to the construction of new visual languages adequate to the realities of the modern world – which contrasts sharply with our own (perhaps guilty) loss of that commitment, a loss that is registered in the buzzword 'postmodernism'. In other words, *our* enthusiasm for the 'low' and the dissolution (or at least the transgression) of its boundary with the 'high' isn't the same as *theirs*. Indeed, the literary historian and cultural critic Terry Eagleton has suggested that postmodernism is a 'sick joke at the expense of revolutionary avant-gardism'. In the commodified artefacts of postmodernism, he argues, 'the avant-gardist dream of an integration of art and society returns in monstrously caricatured form', the Utopian hopes of that earlier time 'seized, distorted and jeeringly turned back on them as dystopian reality'. Why he should say this, whether he's right – and the ramifications and the consequences of his argument for contemporary art – are ideas that we shall explore in this chapter.

From dross to gold

At the heart of Picasso's little *Still Life* construction of 1914 (Figure 10) lies, I have suggested, his creative imagination: foregrounded as the sole means by which, like an alchemist, he turns the 'dross' of discarded materials into the 'gold' of art. This conceit has a richness of implication that belies the extreme economy of its making, for it manages simultaneously to subvert the prevailing conventions of its time as to the proper materials for sculpture; declare (alongside Duchamp's *Bottlerack* (Figure 4) of the same year) the primacy of ideas in the making of art; and stake the claims of imagination – if you like, of genius – to be regarded as first in the hierarchy of such ideas. In this and the dozens of other collaged works made of scrap wood, metal, or pasted papers – the cast-off mass-produced shapes, containers, and images of modern consumerism – that began to fill his studio in 1913–14, Picasso enjoyed demonstrating this alchemical ability, and it eventually became the key term of his art: whatever else it might have to say, from then on that art would

declare his genius in the transformation of materials or forms. His sculptures in particular seem to do so. At the same time, they conduct a guerrilla war against the uniformity and wastefulness of modern consumption, wittily recycling its products in a seemingly effortless transcendence of their banality. Thus two toy cars joined chassis-to-chassis become a baboon's head and a pot becomes its body in *Baboon and Young* of 1951; a water tap is transformed into the head, and a dining fork becomes the foot, of his *Crane* the following year; a rusty gas ring from a cooker is turned into the torso of *The Venus of Gas* in 1945; most famously, a bicycle seat and handlebars are magicked into the *Bull's Head* of 1943.

The deftness of such work is remarkable, the completeness with which it lays bare to the viewer, and depends solely on, Picasso's creative imagination, as amusing yet breathtaking as a clown on a high wire. But like the latter, it relies on a set of skills that he perfected in his youth. For the 1914 *Still Life* construction (Figure 10) not only subverts the then established conventions as to materials, as I have also noted, it also plays off one language of representation against another: the 'ordinary' likeness of the bread and the knife against the 'diagrammatic' display of the glass, its lip and lemon segment. And the latter, to pursue the linguistic metaphor, is in the cubist dialect – a shorthand speech that sparkles with visual puns and associations with different languages of representation such as those of technical drawings, cartoons, or past art. As he elaborated these 'reflexive' properties with Braque between 1909 and 1914, they became increasingly difficult for all but initiates to decipher. This difficulty is crucial. For while he embraced these 'non-art' means and materials in a defiant gesture against the rules, Picasso needed at the same time to resist the collapse of *his* art into those means and materials – to resist, that is, its reduction to commodity status. Thus, in the words of a modern critic, the work of modernists like Picasso 'thickens its textures and deranges its forms to forestall instant consumability'. It didn't always remain so indecipherable; what he brought out of cubism

was a wonderfully flexible set of principles, capable of suggesting and interweaving multiple levels of representation – and it is these principles that inform the sculptures I've mentioned. As they emerged out of his love of cartoons and their graphic shorthand, so they return to cartoon humour in such works. But for other modernists, and for Picasso himself in much of his art, the 'reflexivity' on which these principles were founded, and the 'thickening of textures' – the difficulty of reading – that characterized the works of art they generated, was as important as the alchemy. Picasso's deployment of these qualities was to prove, for later artists, a means of simultaneously acknowledging the vitality of consumer culture and the visual appeal of its forms, and of marking the distinction between these and their art.

This balance (or tension) can be found in the work of the American sculptor David Smith. A member of Jackson Pollock's generation and circle, Smith supported his art practice initially, in the 1930s, with work on a Studebaker automobile assembly line, and the example of Picasso's welded metal sculptures led him to bring the skills of both together, in a 35-year career (tragically, but also ironically, he was killed in a 1965 car accident) that saw the creation of over 750 sculptures. It is a body of work that can be seen to stand at the crossroads of several traditions in modern sculpture, not least in bringing the reflexiveness of cubism to bear on the forms and materials of heavy industry. Like many sculptors of his generation, Smith followed Picasso in the use of 'found' objects; instead of the wearyingly winsome reprise of *Picassiste* humour that soon became conventional, however, he saw the potential of the genre for addressing the issue of representation itself: of how sculpture 'stood for' people, things, or qualities. By the late 1950s, through the incorporation of automobile and machine parts into progressively more abstract sculptures, he had arrived at a set of concerns that, as we have seen, would be articulated a decade later by minimalism and its opponents: the relation between compositional complexity and objecthood, and between 'theatre' and 'presentness' (although

he didn't put it like this himself). The faint traces of particular past identities of the components of his sculptures were dispersed into a generalized association with industrial materials and methods, as his selection of found elements narrowed to the use of prefabricated steelyard shapes, predominantly boiler tank ends, I-beams, and the rectangular stainless-steel sheeting that became his stock-in-trade. In the *Cubi* of 1963–5, a series (incomplete at his death) of 28 stunningly beautiful and often huge pieces whose tonnage was transcended by the deftness of their arrangement and the burnished brilliance of their reflective surfaces, he constructed a homage to the age of steel that was also a sustained engagement with the above sculptural issues. The penultimate work of the series, *Cubi XXVII* (Figure 17) is representative. At once a monumental gateway, barrier, and frame, its shimmering surface and its delicate arc-welded composition that seems to defy gravity combine with its lack of a 'core' and with its inescapably frontal disposition to deny its materiality, even its depth, playing reflexively with the illusion of two-dimensionality like a vast cubist painting in reverse. A long way from the wit of Picasso's *Bull's Head*, it nevertheless references an aspect of the world beyond the studio with a grandeur that is equally compelling.

Smith's trajectory is indicative of the way the reflexive requirements of modernism – its insistence on an artwork's foregrounding of its own materials and conventions – took sculpture in the 1960s progressively towards radical abstractness and away from that lively dialogue with popular cultural artefacts that Picasso had revelled in. Even the challenge of minimalism that emphasized 'objecthood' as the ground zero of the medium, and drew upon the example of Smith's late works to do so, was pitched in formidably abstract terms. But minimalism was a watershed, in more ways than one. Not only did it open sculptural practice to an expanded field of means and methods, as we saw in Chapter 2, but in laying bare the institutional and ideological underpinnings of modernist art – its reliance on that commitment to transcendent aesthetic experience that Fried declared, and to the already-consecrated spaces of

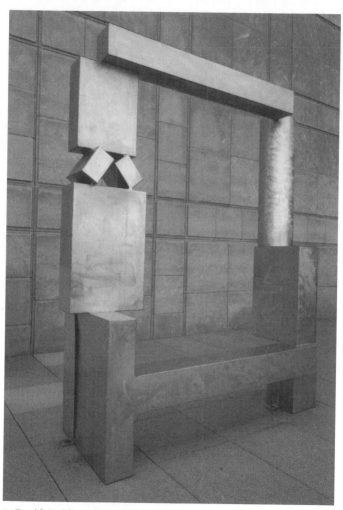

17 David Smith, *Cubi XXVII* (1965).

galleries and art museums as the proper site of this – it enabled the next generation of sculptors to take both for granted, should they choose to. Thus those sculptors who continued to make discrete objects (as opposed to installations, environments, or events) were freed from the modernist obligation to make sculptures that were 'about' their own conditions of existence, and could make overt once again the dialogue with the popular. Several did: in the US, Scott Burton made forms that looked very like Robert Morris's plywood objects, but that were entitled 'chair', 'chaise-longue', and so on; while Joel Schapiro made little shapes in Smith's material of stainless steel that hovered provocatively on the border between abstraction and figuration. In Britain, Tony Cragg piled just-recognizable piston rings and similar machine shapes into exotic-looking clusters of towers and spires suggestive of ancient Eastern cultures or the weathered stacks of Monument Valley, and Bill Woodrow cut and re-shaped obsolete consumer durables into witty configurations, such as the *Twin-Tub with Guitar* or *Car Door, Armchair and Incident*, both of 1981 (Figure 18).

18 Bill Woodrow, *Car Door, Armchair and Incident* (1981).

Drawing inventively on the clichés of popular culture – in this last case, the violence of gangster movies and of comics, with their graphic formulae for shot-gun blasts, etc. – Woodrow's work at once borrows the vitality, accessibility, and ubiquity of such 'low' cultural forms and products, and references earlier moments in the modernist art tradition when similar borrowings have replenished its procedures and devices. Here it is Picasso's example that Woodrow nods to; both the nature of its source material and the wit and dexterity of its manipulation inescapably recall works such as the little *Still Life* (Figure 10). But the acknowledgements of all the other sculptures I've mentioned are, if varied, nevertheless as plain – and they need to be, for such quotation is part of their point, and their legitimation: it is the 'double coding' (as the first chronicler of postmodernism, Charles Jencks, termed it) of such works as *both* 'modern' *and* 'popular' art that carries much of their meaning. The governing stance of such work is ironic: the recycling and juxtaposition of two different already-existing sets of cultural meanings implies a position of amused detachment from both, and implies also a refusal of modernism's distinction between them. But the irony itself depends on the continued existence of those very institutions that maintain this distinction – for without modern art galleries and museums there would be no cultural space for these sculptures, no context within which these meanings can be read.

The society of the spectacle

The post-minimalist (a.k.a. postmodernist, as we shall see) embrace of popular-commercial visual culture by artists from around 1980 was not in itself a new departure, nor was the ironic character of this embrace; both had been preceded by developments of some 30 years earlier. With the return in 1945 of the US economy to a peacetime footing and of its industry to the manufacture of cars and televisions in place of ships and guns, the reservoir of enforced wartime savings of its middle class flooded the marketplace, absorbing as much as could be made and ushering in two decades of

plenty for its luckier citizens. This plenty was imaged in expansionist fantasies of scientific progress, especially space travel, that shaped every product on the market, from automobiles to washing machines, creating an aesthetic of hedonistic excess that was light years away from the rationalism and sobriety of pre-war modernist design, and whose sexiness was celebrated in the burgeonic pop music culture of a newly enriched 'baby-boomer' generation. It was perhaps hardly surprising that artists across the world should share the consumerist enthusiasm for the good life and its visual hallmarks. Even as museums such as MoMA were institutionalizing the avant-gardist critique of capitalism, the appeal of the most vital and demotic elements of its culture, and the potential of these elements as weapons in that critique, were engaging increasing numbers of artists across the world.

Perhaps more surprising was that among the earliest such engagements was that of a group of British artists, since this country had appeared over the previous 30 years deafer than most to the discourse of modernism, and its visual artists, with few exceptions, less adventurous in their avant-gardism than those elsewhere. But the experience of the war and of an egalitarian postwar Labour government had brought about a sea-change in British society, and its young adults in the early 1950s had more social mobility, independence, and disposable income than their predecessors. Scottish sculptor Eduardo Paolozzi was one of these. As awareness of American popular-commercial culture grew in the postwar decade, Paolozzi developed an infatuation with it, which he expressed at first by filling scrapbook after scrapbook with collages made of cut-out images from the imported American magazines that he obsessively collected. Frequenting London's recently founded Institute of Contemporary Arts, Paolozzi discovered that he was not alone among artists and cultural commentators in his passion. With the architectural historian Reyner Banham, artist Richard Hamilton, and a few other like-minded aficionados of what they called this 'aesthetic of plenty', he founded the Independent Group, which met regularly

to exchange ideas, enthusiasms, and new discoveries in the Aladdin's cave of US product design, advertising, and comic-hero imagery.

The shared enthusiasm was deep. It was driven partly by a keen and envious awareness of the gulf between the austerity and drabness of consumer culture in a Britain still subject to rationing of most commodities, and what seemed to be the abundance and sensual excitement on offer in the American marketplace; partly by an appreciation of the difference between the democratic freedom, vitality, and openness to novelty of the culture which that marketplace generated, and what the group saw as the suffocating conservatism and snobbery that still governed British cultural attitudes. But the affection was laced, too, with ironic recognition of the implications, not only for 'high' art but for modern culture in general, of the influence and spread of this commercial culture. It was registered in Paolozzi's case in the ambivalence of the robotic figure sculptures that he began to make, swapping an interest in vegetable forms that had shaped his earlier sculpture for mechanical and electrical elements which he cast from discarded appliances found on waste tips and in car-wrecking yards. This series of giant heads and over-life-size figures – constructed in plaster (and then bronze) from (to quote a list Paolozzi himself compiled) '[a] dismembered lock, toy frog, rubber dragon, toy camera, assorted wheels and electrical parts, clock parts, broken comb, bent fork', and much more – is at once funny and menacing, a cast of comic-book Frankenstein's monsters for the consumer age.

Deploying an equivalent irony, though in a different register, Richard Hamilton began in the mid-1950s to make paintings that drew on US consumer product styling. *Hommage à Chrysler Corp* of 1957 collaged details of (among other models) Chrysler Plymouths and Imperials of that year, taken from adverts: fenders, headlamps, and grilles whose lovingly rendered surfaces played off their stylistic brio against the associations of the tradition of French modernist

painting suggested by the title. Mischievously juxtaposing 'high' and 'low' aesthetics, Hamilton, who had already enjoyed a substantial career as an industrial draughtsman, presented in *Hommage* an anthology of presentation techniques that recapitulated Picasso's innovations of 1912–14, updating them for a new consumer age. And in some cases, giving them a sharper critical edge: as in *$he* of 1959–60, which substituted kitchen and cosmetic technology for automotive, laying bare the constructed image of the modern domestic goddess via a knowing montage of fetishistic details: pouting lips, bare shoulder, toaster-cum-vacuum cleaner, open fridge. Yet despite such irony, Hamilton's enthusiasm for US commercial culture is, like Paolozzi's, unmistakable. In a list of qualities that is an equivalent of Paolozzi's compilation of objects, he offered in 1957 a definition of what he then termed 'Pop art' (that is, popular commercial art):

> Popular (designed for a mass audience)/Transient (short-term solution)/Expendable (easily forgotten)/Low cost/Mass produced/ Young (aimed at youth)/Witty/Sexy/Gimmicky/Glamorous/Big Business . . .

If works such as *Hommage* and *$he* are indebted to the example of Picasso – and perhaps also to Schwitters, in the meticulousness with which their visual quotations from the everyday are marshalled – their accessibility, and their frank acknowledgement of the aesthetic qualities of consumerist styling, place them closer to this culture than to the hard-to-read images and opaque language of those modernists.

Elsewhere in Europe, too, artists were taking stock of consumerism and its visual culture, and in ways that registered the particular political and social postwar context in which the impact of these were felt. In France, intense interest in American products and their marketing was refracted through both a political culture in which the Communist Party was still strong, and an artistic community which, though riven by the resulting political factionalism, was keenly aware of its own illustrious history. A group of *'Nouveaux*

Réalistes' sought a middle way between the ideological polarities of American Abstract Expressionism and Soviet Socialist Realism. Drawing on the example of Dada with work that incorporated real objects, artists such as Arman, César, and Martial Raysse could not, however, recapture the punch of Duchamp's ready-mades, or re-stage the challenge to artistic hierarchies that these had presented, and the subversive impact of their arrangements of discarded toys, tools, and the like tended to be blunted by a tasteful picturesqueness. More challenging work emerged from 1950s and early 1960s Germany, where the presence of US troops was still ubiquitous, where steady economic recovery reinforced a collective resolve to suppress the experience of Nazism, and where the alternatives of Western consumerism and Stalinism were next-door neighbours. From the late 1950s Gerhard Richter, Sigmar Polke, and one or two others elaborated a kind of painting whose engagement with images from daily (often consumer) experience was charged with wicked, if often deadpan, irony. Their self-styled 'Capitalist Realism' displayed a close familiarity with the work of contemporary US Pop artists – Richter paralleling Warhol, as we've seen in an earlier chapter, in his play with photographic imagery; Polke appropriating the printers' dots technique of Lichtenstein – but their 'take' on both the imagery and the techniques which characterized that art was oblique, and implicitly subversive of the role of the artist as cultural critic. In a notebook of 1964–5, Richter described his excitement at 'finding out that a stupid, ridiculous thing like copying a postcard could lead to a picture', and at 'the freedom to paint whatever you felt like. Stags, aircraft, kings, secretaries . . . '. For his part, Polke not only used the printers' dots technique with a carelessness and lack of 'professionalism' that was quite unlike Lichtenstein's work, but embraced the most 'debased' of graphic media, such as ball-point pens, rubber stamps, and poster paints, to make images that echoed the work of the Dada artists (and anticipated some recent graffiti art) in their evident lack of investment in skill or taste.

Perhaps because they were so steeped in it, the American artists

19 Detail from James Rosenquist, *F-111* (1965).

who addressed their own popular culture seemed to do so more
directly than these Europeans, borrowing its imagery and
techniques for work whose verve was as appealing as its subject
matter was accessible. If a painting like James Rosenquist's 26-
metre-long *F-111* of 1965 (Figure 19) lacked the edginess and irony
of work that refracted US culture from an ocean's distance, its sharp
and polished montage of emblematic images of the contemporary
American way of life nevertheless punctured like a thunderclap the
complacency of Greenbergian formalist assumptions about what
was proper to art. Its huge size and visual immediacy referenced the
idiom of billboards, while its impersonality of technique, surface
polish, and abrupt shifts of scale challenged the very premises of
abstract art, be this expressionist or formalist.

What it didn't do, however – and it had this in common with most
US pop art – was call commercial popular culture itself into
question, as the Europeans had (if often obliquely). That culture
was, for US pop artists, both a means of challenging the elitism and
inflated individualism of American abstraction, and an object of an
enjoyment that was sometimes fiercely expressed, as in Claes
Oldenburg's statement of his artistic credo: 'I am for an art that is
political-erotical-mystical, that does something other than sit on its
ass in a museum', he declared in a 1960 manifesto,

110

I am for the art that a kid licks, after peeling away the wrapper . . .
I am for the blinking arts, lighting up the night. I am for art
falling, splashing, wiggling, jumping, going on and off . . . I am for
Kool-art, 7-UP art, Pepsi-art . . . 9.99 art, New art, Fire sale art,
Meat-o-rama art

But only rarely was commercial culture engaged with in order to
question, far less confront, its own implications or consequences.
Almost unique in mounting such a challenge was the work of the
Los Angeles sculptor Edward Kienholz. Combining consumer
objects and repulsive-looking mannequins to present disturbing
tableaux of slices of American life (the automobile as passion pit in
Back Seat Dodge of 1964, the inside of a diner in *The Beanery*
(1965), a seedy brothel in *Roxy's* of 1963), Kienholz constructed
what one US critic described as a series of bizarrely gothic allegories
on the decay, human contamination, and psychic disorders
underlying the banality of everyday life in the USA. Honed by the
mounting protests of the later 1960s over Vietnam, the critical edge
to this work reached its sharpest with Kienholz's *Portable War
Memorial* of 1968, a powerful sculpture that not only bitterly
exposed the myth of patriotism that had licensed America's
successive, and increasingly violent, imperial adventures since 1945,
but used the seductive appeal of its equally mythic consumer
culture to secure the viewer's complicity in that history (Plate V).
This ten-metre tableau tellingly juxtaposes iconic aspects of that
patriotism and culture – positioning a dustbin-bodied mannequin
with the voice of Bessie Smith singing 'God Bless America', an
Uncle Sam 'I Want You!' army recruiting poster, and a sculptural
replica of the famous (and famously contrived) war photograph of
American soldiers planting the stars and stripes on Iwo Jima to
celebrate victory over Japan in World War Two, in front of a mock-
up American diner with usable coke machine, chairs, and tables –
and a blackboard listing 475 nations that no longer exist because of

wars (with a piece of chalk on a string, for adding future names). Metaphorically extending US imperialism and its war machine into the realm of consumption, the work offers a bitterly ironic critique of what used to be called 'coca-colanization'. But it also does more: its café-terrace invitation to the gallery viewer to stop for a coke presents a frontal challenge to assumptions both of a cultural hierarchy distinguishing 'high' art from 'low', and of 'high' art's transcendence of the space of everyday life. There is no barrier between viewer and tableau other than those prohibitions that govern gallery-going behaviour.

The sharpest artistic critique of the consumer society that Western capitalism, led by American corporations, had created came, however, and perhaps inevitably, from the Parisian avant-garde – indeed from what was probably the last grouping within that avant-garde for whom its traditional commitment (which I discussed in Chapter 1) to political and aesthetic radicalism was a fundamental credo. The Situationist International, founded in 1957, drew together the disparate strands of avant-garde Marxism and surrealism into art activities and proclamations that were as directly confrontational to the existing political and cultural order as they were marginal. Almost invisible, inaudible, and (when their publications could be found) unreadable, the Situationists' attempts to subvert the cultural order by means of ironic graphics and cartoons fly-posted across Paris were meaningless to all but their membership, until a decade later they found themselves at the centre of the student uprisings on the city's left bank, and their slogans – 'Be realistic: demand the impossible!', 'under the cobblestones, the beach' – became rallying-cries for the riots of May 1968. The year before, the leading Situationist Guy Debord had published *The Society of the Spectacle*, a collection of 221 aphoristic comments on contemporary capitalism whose pithiness was in proportion to their severity. He declared:

> The entire life of societies in which modern conditions of production reign announces itself as an immense accumulation of

spectacles. Everything that was directly lived has moved away into a representation . . . The first phase of the domination of the economy over social life had brought into the definition of all human realisation an obvious degradation of *being* into *having*. The present phase of total occupation of social life by the accumulated results of the economy leads to a generalised sliding of *having* into *appearing* . . . The spectacle subjugates living men to itself to the extent that the economy has totally subjugated them. It is no more than the economy developing for itself.

Crisis of modernism

Debord's observations, of course, reached only a miniscule audience at the time, although his insights have since become widely accepted and (selectively) appropriated, as we shall see. For all the brio with which they were briefly taken up on the streets of Paris, their edge was blunted by the much broader appeal of another 1968, and one that was represented by another city. Whereas Paris stood for protest, San Francisco stood for pleasure, and while political and personal licence were at first as closely associated there as for the Situationists, the rights of pleasure and of desire that the hippy movement asserted were quickly separated off, then held against the 'straighter' political demands of Parisian radicalism, and finally commodified into 'lifestyle' alternatives. By the end of the 1960s, the fallout from the upheavals of 1968 had begun to settle into two patterns. On the one hand, the result was a massive loss of confidence (and, for some, of faith) in the ability of leftist politics and related cultural protest to achieve social change; on the other, the libertarian fantasy of unlimited social and sexual licence was transformed into a means for selling more consumer products. As the magnetic appeal grew of the lifestyle dreams it marketed, the 'society of the spectacle' neutralized the critical charge, such as it had been, that modernism in all its variants, from Dada to pop, had generated – dismantling the cultural hierarchy of 'high' and 'low', seemingly achieving just that reintegration of art with social life that the revolutionary avant-gardes of the early years of the 20th

century had sought. For those who saw themselves as the heirs of that avant-gardism, it seemed, as Terry Eagleton suggested in the remark I quoted earlier, that the Utopian hopes of that earlier time – those hopes for spiritual revolution expressed in André Breton and the surrealists' attempts to 'liberate desire' with shocking images (Figure 2), as well as for the social revolution that Vladimir Tatlin celebrated in his soaring *Monument to the Third International* (Figure 5) – were being 'seized, distorted and jeeringly turned back on them as dystopian reality' by the relentless colonization of art by consumerism.

For others, though, this 'marriage of commerce and culture' amounted to a liberation of art from the ghetto of self-absorption and austerity that it had been led into by the insistence of Greenbergian doctrine on modernism's autonomy and self-referentiality, and by conceptualism's pursuit of these into the depths of its own navel. 'Pleasure' was now at the top of the agenda in place of 'purity', and accessibility seemed more important than reflexivity. The sense of a break with a modernism whose principles seemed out of step with the contemporary (Western) world was expressed in the coining of a term, 'postmodernism', that from the late 1970s to the present has gained in currency with every year that has passed, its meaning becoming steadily more blurred as it has done so. Even by 1988, cultural commentator Dick Hebdige was able to suggest that

> when it becomes possible for people to describe as 'postmodern' the décor of a room, the design of a building ... a television commercial ... the layout of a page in a fashion magazine ... the collective chagrin and morbid projections of a post-war generation of baby boomers confronting disillusioned middle age ... the collapse of cultural hierarchies, the decline of the university, the functioning and effects of the new miniaturised technologies ... when it becomes possible to describe all these things [and his list is actually twice as long] as 'postmodern', then it's clear we are in the presence of a buzzword.

As such, its usefulness in pointing to distinctively contemporary cultural attitudes has perhaps long since disappeared. But 'postmodernism' used to mean something, or some things. Mostly, it pointed to a contemporary recognition of the ubiquity of the images from television, advertising, newspapers, and films, and the consumer products with which they are associated, that saturate our societies of the West (and fuel their economies); an acquiescence in their power to direct the shaping of our ideas, imagination, and sense of reality; an acknowledgement of their inter-relatedness, and even apparently self-generated nature. As postmodernism's first theorist, Jean-François Lyotard, put it in his book *The Postmodern Condition*:

> eclecticism is the degree zero of contemporary general culture: one listens to reggae, watches a western, eats McDonald's food for lunch and local cuisine for dinner, wears Paris perfume in Tokyo and 'retro' clothes in Hong Kong; knowledge is a matter for TV games.

This recognition led to a questioning of assumptions of our individuality and the stability of our subjectivities; both were instead seen as provisional, changing, even 'constructed' by the self-identities that we are offered in the social (and increasingly global) play of images.

From such questions and propositions, others followed. The idea of so-called 'metanarratives', that is, overarching explanations of the human condition, or of the dynamic of history – such as those offered by Christianity, or Marxism, or the notion of the inevitable progress of civilizations – was rejected along with the absolute certainties on which they rested, since all had been built on (what were now seen as) the shifting sands of individualism. They were replaced by relativism, uncertainty, and an acceptance (enthusiastic and optimistic by some, resigned and cynical by others) of the provisional and partial nature of 'truth'. These are big philosophical issues, and we can't pursue them here for their own sake. But they were explored in art practices through the prevalence of artistic

strategies and devices that played on, and with, the 'ready-made' character of images and meanings – the inevitable prior associations and implications that any visual mark or representation brings with it – and they were expressed in cultural criticism by an emphasis on the 'break' between these strategies and those of modernism. Lists that compared and opposed them became fashionable in the 1980s: architectural critic Charles Jencks (who did most to disseminate the concept of postmodernism in its early 1980s heyday) offered no less than 30 such oppositions. Postmodernism, he asserted, is 'popular' where modernism was idealist, semiotic versus functional, complex versus simple, eclectic versus purist, humorous versus straight, ambiguous versus transparent, collaged versus integrated, and so on.

Jencks suggested, tongue in cheek, that the postmodernist era began at 3.32 p.m. on 15 July 1972, when a typically idealist-functional-simple-purist-humourless (etc.) housing complex in St Louis, Missouri, was dynamited to make way for something more popular-semiotic-complex-eclectic-humorous (etc.). His point was to emphasize (and many would say exaggerate) the break from modernism that it represented; but postmodernism, once identified as a *Zeitgeist*, did spread around the world with extraordinary speed and vitality, and equally extraordinary visual consequences. In architecture, the difference was like night and day between say, London's Centrepoint tower and Terry Farrell's makeover of Charing Cross station, with its jukebox-like river façade; or between the same architect's neo-art deco MI6 headquarters of 1995, a building 'cool' enough to star in a James Bond movie, and the sleek severity of the 1960s Millbank Tower across the river. Museums like Frank Gehry's Guggenheim Bilbao or Oscar Niemeyer's Museum of Modern Art at Rio de Janeiro (both designed in the early 1990s) are, notoriously, as unlike previous museum buildings as it is possible to be. In art too, the opportunities presented by what seemed a new licence to play not only with the images and techniques of commercial culture but the products themselves was seized by some artists with both hands. From the

early 1980s Israeli-born New Yorker Haim Steinbach arranged groups of newly purchased, pristine objects – vases, footballs, plastic toilet brushes, trophy cups, beer cans – on wall-mounted shelves, bringing sculpture very close to store display (and art viewing to window shopping). Even more provocatively, Jeff Koons, another New York artist (and former Wall Street commodity broker) selected the kitschest consumer objects he could find – inflatable pink bunnies, gold-coloured ceramic Michael Jackson figurines – for equally deadpan displays, stretching Marcel Duchamp's (circa 1913) idea of the ready-made to the point where 'art' and 'taste' parted company. Koons later flirted with pornography, exhibiting life-sized photos and tableaux of his Italian porn-star/politician wife 'La Cicciolina' and himself having sex – explicitly ackowledging the desire that drives the fetishistic appeal of commodities.

As art historian Brandon Taylor has observed, perhaps the most that could be said for this American commodity art was that, in its embrace of popular-commercial culture, 'it contained a sort of pragmatic acknowledgement of the failure of classic models of socialism, both in Eastern Europe and the West'. But this judgement was based on continued modernist assumptions of the critical role of modern art – and from this perspective, as he adds, 'the notion that the redisplay or evocation of consumer objects could provide an effective critique of commodity culture was at best utopian in the market zeal of the 1980s'. Koons, for one, was not interested in such a critique – rather the opposite, since both his assemblages and his jokey persona are at one with that culture. Others working with such materials were interested, however. Several British sculptors who came to prominence in the 1980s, such as Tony Cragg, Bill Woodrow, Julian Opie, and David Mach, all made work out of domestic rubbish that had an implicit, and sometimes explicit, critical edge: for example Cragg's use, in sculptures of the early 1980s, of found plastic kitchen waste – bleach and toilet cleaner bottles and other packaging – had unmistakable social and environmental connotations. Yet the relish

with which their products were taken up by the market suggests that their efforts had little purchase – if the pun will be permitted – on cultural attitudes. For such purchase requires that the position from which any critique of commodity culture is made is itself independent from it; like Archimedes' lever that would move the world if only he could find a fulcrum, it needed a point of anchorage *outside* of consumerism's gravitational pull. And these were increasingly hard to find, for two reasons. First, because the institutionalization of the avant-garde that I traced in Chapter 1 had already fenced in the spaces of art practice, and art museums themselves were increasingly indistinguishable from shops. Their sales and leisure areas were relentlessly expanding from the early 1980s as many museums saw the financial benefits of offering a mixture of high-cultural allure and consumerist diversion ('an ace caff with a nice museum attached' was the notorious slogan adopted by Roy Strong's Victoria and Albert Museum at that time). For their part, retail chains saw the same benefits from the other side of the street. Anyone who has been to the underground shopping mall beneath the Tuileries in Paris before or after visiting the refurbished Louvre next door will have noticed the eerily similar design, and high production values, of both. Recognizing that contemporary art, in particular, could be relied upon to deliver to them the style-conscious young opinion-formers in their target A, B, and C1 market groups, companies in the UK such as Harvey Nichols, Selfridges, Monsoon, and Jigsaw began to mount art exhibitions in-store, while Habitat published an *Art Broadsheet* with invitations to such exhibitions, following a strategy of 'relationship marketing'.

But the cultural spaces beyond the pull of consumerism were also being closed out by the commodification of history itself. The avant-garde's awareness of alternatives to the present cultural and social order was the foundation for its cultural critique, and its self-positioning in between these was shaped by a belief in the underlying dynamic of historical progress. But postmodernism not only called into question the very idea of progress; its endless recycling of images and its celebration of the role of fashion in the

equally endless construction and reconstruction of identity relentlessly reduced the past to a marketplace, where one historical moment is the equivalent of any other, and no more connected to our lived experience of the present than a picture on TV. How then were artists who were still committed to cultural critique going to resist what the US critic Benjamin Buchloh called, in that phrase I quoted earlier, 'the tendency of the ideological apparatuses of the culture industry to occupy and to control all practices and all spaces of representation'? In a 1983 essay another US critic, Hal Foster, suggested the beginnings of an answer:

> In cultural politics today, a basic opposition exists between a postmodernism which seeks to deconstruct modernism and resist the status quo, and a postmodernism which repudiates the former to celebrate the latter: a postmodernism of resistance and a postmodernism of reaction ... A resistant postmodernism is concerned with a critical deconstruction of tradition, not a ... pastiche of pop- or pseudo-historical forms, with a critique of origins, not a return to them. In short, it seeks to question rather than exploit cultural codes, to explore rather than conceal social and political affiliations.

It is in this context, as well as that of the feminist movement in which I discussed it earlier, that the work of American artists Cindy Sherman (Figure 14) and Barbara Kruger can be situated: the ways in which Sherman 's endless masquerade of female personae deconstruct modern femininity, and Kruger's assertive graphics mock, as they mimic, the confected hype of lifestyle magazines, are telling examples of the adoption of popular/commercial styles and motifs for critical, rather than celebratory, purposes. Others include Chicago artist Leon Golub's wall-sized paintings that depict subject matter more likely to be found on the TV news – scenes of 'terrorist' interrogation, or of 'freedom fighters' in full regalia – in a manner that combines the colour-saturated surfaces of Newman or Rothko with the figurative conventions of war comics (Figure 20). Their effect is to confound our expectations of what a modern painting

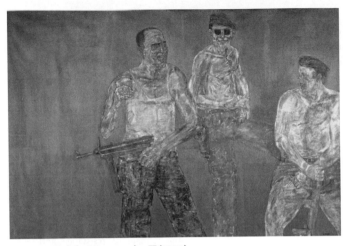

20 Leon Golub, *Mercenaries II* (1979).

can offer us beyond aesthetics – simultaneously appearing to reclaim for painting that political relevance which Picasso's *Guernica* so famously asserted 70 years ago, it seemed for the last time, and yet underscoring, in the sheer improbability of its stylistic coupling, the gulf that now yawns between painted and newsreel images. Rachel Whiteread, with whose 2001 sculpture *Monument* (Plate I) this book opened, can be seen from this perspective, too: her 'conceit' of casting in plaster, latex, or resin the spaces we inhabit, and sometimes the solids we ignore, in our daily lives offers a deceptively simple, but imaginatively potent, means of distancing ourselves from these and seeing them anew. The furore that burst over her 1992 Turner Prize-winning *House*, and caused its demolition, at least had the merit of demonstrating the emotive charge that such a deconstruction of modernist ideas of sculptural 'objecthood' can generate. On the other hand, perhaps it also made plain the pitfalls of trying to make art that contests the assumptions with which we occupy the domestic and social spaces of our lives. Certainly, 'critical' and 'postmodernism' have proved to be two terms whose coupling has been easier to propose than to realize – or at least to sustain.

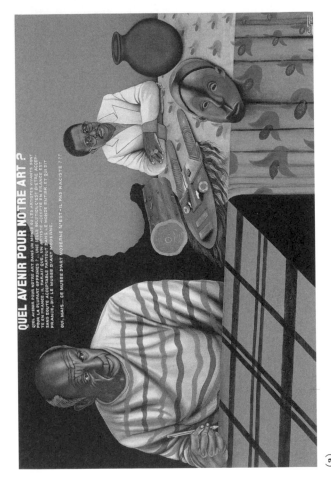

(a)

VI Chéri Samba, *Quel avenir pour notre art?* [*What Future for Our Art?*] (1997).

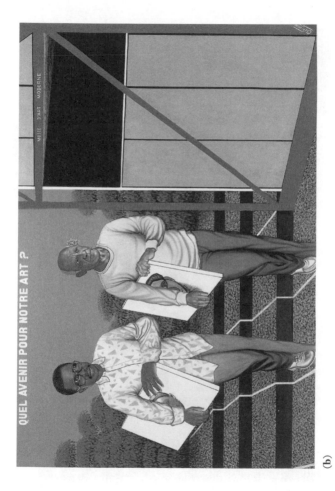

(b)

Chapter 5
Past the post:
whatever next?

Where has postmodernism left modern art, and us, its audiences? For good or for ill, it appears to have been a cultural upheaval on a scale unprecedented since the one ushered in a century ago by the emergence of the avant-garde. As I have shown, those earlier developments in modern art overthrew established ideas about what art was, who could make it, what and whom it was for. In place of a narrow range of accepted materials and practices – oil or watercolour; bronze or marble; painting, printing, or sculpting – it enabled artists to make use of whatever means they chose for the purposes of self-expression. It replaced a carefully guarded middle-class profession with an occupation open to anyone with creative imagination and ambition. Instead of a cultural hierarchy that placed grandiose public art above intimate and private decorations, it fostered a theatre of images, media, and ideas in which political purpose and personal delight fought and embraced each other, and whose audience was – it was hoped – as diverse as its performances.

How, in its turn, has the cultural upheaval we call postmodernism affected our understanding of modern art? To answer this question, we need first to be clear about its terms. To start with, we should recognize that 'modern' is a more complex label than it may seem. Unlike other art historical labels such as 'renaissance' or 'baroque', it refers not only to a period or an epoch, but to the present time as

well – in any normal usage, 'modern' means today as well as the recent past: we live in the modern world, we use modern technology, et cetera – none of this would make sense if 'modern' referred only to the recent past. And in normal usage, too, 'contemporary' means the leading edge of the modern – the *most modern* moment. Thus it follows that 'contemporary art' is *a part of* 'modern art', not distinct from it; Damien Hirst is a modern, and also a contemporary, artist – the additional designation helps to locate him within modern art, but does not as such distinguish him from it. Thus the qualities of modern art that I've been exploring and explaining in this book, and that have been exemplified by many artists of the last 150 or so years, provide the broad frame of reference for understanding his art and that of other contemporary artists.

We should also recognize that 'modern' is a term that separates its period from its predecessors in a way that, say, 'renaissance' does not – partly because there is a value judgement hidden within the term, which makes the separation qualitative as well as chronological. To be 'modern' is to have qualities that Western societies currently value – vitality, openness to the new, responsiveness or relevance to the present moment, for instance. This qualitative dimension is one that's heavily leaned upon these days, as you may have noticed, by politicians who wish to avoid the need to justify their policies in more specific terms; to 'modernize' something means to improve it, enough said – or so they hope. Similarly, the reason why 'modern art' is a term that distinguishes the most important art of its time from all the other art that was made in this period is that it can be shown – as I hope I have – to display these qualities I've suggested; although the ways in which they are displayed in each case is often puzzling (as in, say, Jackson Pollock's painting) if not perverse (as in, say, Duchamp's work), and hence the bewilderment, even the hostility, of its audiences. Art historians call such art modern*ist* art – and have meant by this term, as we've seen, a number of things.

We should, however, recognize on the other hand that 'modern' *does also* designate a period, or epoch. Even if it hasn't ended (in that this is still the modern world), it had a beginning. Just when this was, is a question still in some dispute among social and cultural historians, the leading alternatives being the beginning of capitalism in 14th-century Europe, and the late 18th-century 'moment' of the Industrial and French Revolutions. Art historians take the latter option, although the artistic response to the epochal changes that modernized the Western world – the response we call modernism – is generally agreed not to have got underway until the mid-19th century. In so far, then, as there is a 'modern' period, designated as such according to certain historical criteria, it is quite possible to ask whether we should assume that this period is going to continue indefinitely, keeping up with the present by definition, as the above normal usage of the term suggests – or whether it is more likely that those historical criteria, those conditions that ushered in the modern period, might be subject to change, as such conditions have in the past.

And this is where the concept of 'postmodernism' is relevant; for it has been disseminated as a means of claiming that modernism, or even – for some proponents of the idea of the postmodern – the modern period itself, has also now come to an end. For our understanding of modern art, the value of this claim, in either version, lies in its identification, and its explanation, of the factors that characterized this ending of an era and its succession by a new one. I discussed these factors, and the crisis of modernism in the *making* of art that they brought about, in the last chapter. What has been their consequence for the ways in which this art has been *received* – that is, on how today's art audiences appreciate modern art? Has postmodernism brought about a separation, after all, between our responses to 'modern' and to 'contemporary' art?

New ways of seeing

Among the most visible developments in the reception of modern art has been the extraordinary growth in recent years in the numbers of people visiting 'blockbuster' exhibitions of what we could call 'blue-chip' modernism, in particular retrospectives of the work of major modernist painters. Exhibitions of Cézanne, Matisse, Picasso, and even – given the austerity and apparent emptiness of his abstract paintings – Rothko in the capital cities of the West in the past decade have drawn unprecedented numbers of viewers, and required previously-unheard-of crowd management strategies of advance booking and timed entry. Is this an expression of a nostalgia for the relative certainties of meaning (and of aesthetic reward) obtainable from painting, even modern abstract painting, in the face of the free-for-all that is contemporary art? If so, then it would mean that the rough-edged iconoclasm and outrageous inventiveness for which modernist artists were both celebrated and condemned not so long ago have been worn down surprisingly quickly, softened into accustomed cultural 'furniture' – ironically, to function rather like the 'armchair for a tired businessman' that Matisse in 1908 hoped, optimistically, that his painting would be seen as. This may be part of the reason. For Picasso was the key figure for modern art through most of the 20th century, and the vigour and outrageous inventiveness of his imagination were both a model for modernist art-makers and a target for their opponents; but the ascendancy of conceptual art in the 1970s and thereafter was secured on the shoulders of Marcel Duchamp – and so unforgivingly, obscurely intellectual was the new model of art-making that *he* offered, that the visual complexities of post-Picasso painting have perhaps seemed sheer hedonism in comparison.

There is more in this fondness for painting than distaste for its contemporary alternatives, though. I quoted earlier Michael Fried's assertion that the encounter with a work of art offers the experience of a 'state of grace' which lifts us, momentarily, above

the mundanity of our daily lives; this sounds a distinctly religious kind of experience, and it does seem that in our increasingly secular societies, aesthetic transcendence is one of the few substitutes on offer for those formerly brokered by the organized religions, of the West at least. So rather like the nostalgia for country living and landscapes that sweeps the ordinary, unpretty realities of both under a carpet of myth, viewing paintings, whether those as obscure and challenging as Picasso's or Pollock's, or as life-affirming as those of Cézanne or Matisse, offers an experience that is familiar, predictable, and soothing: in a word, consecrated, like the space of a chapel. Given this, it is no surprise that one of Mark Rothko's major commissions, and subsequently most celebrated works, was the suite of paintings he made in 1970 for the de Menil family chapel in Houston, Texas – or that this is one of the most popular destinations on the US modern art tourist map.

Yet it is also evident that the legitimated media and masters of modernism are not all that today's art audiences wish to see; as the large and growing numbers of visitors to the Tate's annual Turner Prize exhibitions show, contemporary art also has a broad appeal. Nor is this because it offers opportunites for indulging in ribaldry and ridicule like that enjoyed by early modernism's audiences, at Manet's or the cubists' expense. In the century since the Parisians of the *Belle Epoque* and Edwardian Londoners laughed themselves silly at the antics of their avant-gardes, our dispositions and our expectations of art have changed – in part, as a result of changes in our working lives. In the modern office, the rapid accumulation and manipulation of information from diverse sources, and in 21st-century manufacturing, the rapid and increasingly automated assemblage of equally widely sourced components, have translated over into a greater readiness to see the artist, too, as the organizer of disparate materials and signifying processes, and not solely as the possessor of developed craft skills of painting, carving, or modelling. Judgements about artistic quality are no longer as dependent as they once were on requirements of manual dexterity.

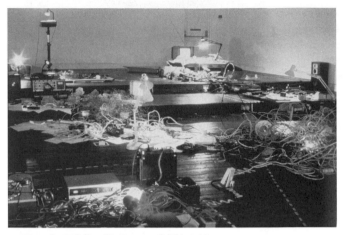

21. Tomoko Takahashi, *Beaconsfield* **(1997).**

Thus, to take just one example, Tomoko Takahashi's installations that I described earlier (Figure 21), which recycle discarded electrical or electronic equipment from office skips into roomfuls of buzzing and flashing piles of wired-up junk – art such as this resonates with our working experience on a number of levels, and draws wry smiles of recognition from its viewers. The humour resembles that afforded by Picasso's found-object sculptures, and stands in a direct and perhaps self-conscious line of descent from these, but it is not so much Takahashi's wit that is the motor or the meaning of the work, as its tapping into that profound ambivalence towards the relentless march of technology that we share, in different ways, in our working lives. This is not alchemy, and the raw material remains dross; but it is the dross of *our* lives, and Takahashi's artistic vocabulary is that of our vernacular. As I suggested earlier, since minimalism's deconstruction of what we might call the 'art-status' of art objects, and postmodernism's subsequent challenge to the boundaries between 'high' art and commercial culture, this common ground between art and everyday experience has been a feature of much installation art. So perhaps to this extent, there *is* a difference between how we understand

'modern' and 'contemporary' art. But as I also noted, the dismantling of cultural hierarchies is more apparent than real: the growth of art *museums* has registered, among other things, the enhancement of their cultural authority. It is still (increasingly?) within the museum that we experience most modern and contemporary art, and – as Tate Modern's unconventional display policy, with its juxtapositions of contemporary and modern art in themed surveys, demonstrates – it is on the museum's terms that we understand it.

A world of difference

It is not only the modern and contemporary art of the West that draws ever greater attention, however, nor only the presumed boundary between 'high' and commercial art that postmodernism has put under strain. Alongside the changes to the working lives of most people in the West, the modern globalized economic order has brought different regions of the world together in a variety of ways. On the cultural level, the result has been a greater awareness in the West of the existence – and equal validity – of different cultural traditions and inheritances. With this has grown an acknowledgement in the previously all-powerful art capitals of the USA and Europe of *other* art centres, art publics, and artistic conventions. Prompted by that 'critical postmodernism' that I noted in the last chapter, this awareness and this acknowledgement have developed slowly, and one of the principal means (as well as markers) of their dissemination has been the series of major museum exhibitions mounted on both sides of the Atlantic over the last two decades. These 'blockbuster' shows have registered the several phases of our emerging engagement with 'world art'.

The first phase was that of an acknowledgement of the indebtedness of Western modern art to the traditional art of non-Western cultures. Exhibitions such as the New York Museum of Modern Art's 1984 show *'Primitivism' and 20th-Century Art:*

Affinity of the Tribal and the Modern, and in 1985 the Royal
Academy's *Africa: The Art of a Continent* opened their Western
viewers' eyes to the beauty and inventiveness of African art. But
they also maintained an understanding and a positioning of
this art as subservient to the modernist art, such as that
by Picasso, Matisse, or the German expressionists, that it
influenced. Juxtaposing the 'tribal' with the 'modern' implied
that African artistic identity was subsumed in supposedly
timeless social collectives; presenting that identity as 'continental'
locked African artists even more inescapably into a predetermined,
traditional frame of reference. Western art, by explicit contrast
(in the case of MoMA) or by implication (in the case of
the Royal Academy), is the product of individual and
untrammelled encounters with the modern world we live in.

Yet partly in response to the tired clichés of this approach – the
MoMA show in particular drew heavy criticism from artists, critics,
and Africanists alike – and partly prompted by the new perspectives
opened up by the postmodernist challenge, a second approach to
modern non-Western art emerged in the West. The huge 1989
exhibition in Paris, *Magiciens de la Terre*, exemplified this
approach. It sought to place art from all over the world on an equal
footing, acknowledging each selected artist as a modern, individual
creator regardless of in which continent, and in relation to which
cultural tradition, he or she worked. But such an aim was also
problematic, for it could only do so – could only find that coherence
necessary for any successful exhibition – by assuming a singular
'modernity' that all its exhibitors faced, in different ways. Thus
non-Western art could only be assimilated to the 'modern' by
celebrating what its curators saw as the hybrid, the pastiched, and
the ironic qualities of this art. Among the most thus celebrated were
Ghanaian Samuel Kane Kwei's coffins that were shaped after
objects connected to the former occupation of the deceased – a
Mercedes for the former owner of a taxi fleet, for instance, or a boat
for a fisherman – and Congolese Chéri Samba's 'popular paintings'
(as the artist himself styles them) which mix African and Western

art styles and themes, and texts in French and Lingala, with bright colours and ribald wit.

Samba's triptych *Quel avenir pour notre art?* [*What Future for Our Art?*] of 1997 (Plate VI) is typical of his work. In the first panel the painter depicts himself seated behind a table strewn with African masks, and beside Picasso, who is seated, pencil in hand, at a table whose gridded tablecloth suggests the kind of abstract painting that Mondrian derived from cubism. Both African and cubist artists, Samba thus implies, have been powerless to prevent the misappropriation of their work by others. (Samba's irony here is biting: it was precisely cubists such as Picasso who were among the first to undertake this misappropriation of African art!) The other two panels show Samba and Picasso each with a canvas beside a modern building that resembles the Centre Pompidou art museum in Paris, and Samba himself in a crowd in front of the Pompidou's recognizable façade; the accompanying painted text questions the ghettoization of African artists in such museums, and the lack of examples of their work in major exhibitions. The combination of droll irony, inter-cultural reference, bright colours, and accomplished portraiture are typical of the qualities that have made this artist's work sought-after by collectors both in Africa itself and in the West. But while this current of commentary on the relation between Western and African interests and cultures, which runs through much of Samba's painting, offers insights for viewers in both arenas that are often sharp and funny, does it nevertheless continue to position those Western interests and assumptions as the dominant part of each pairing? And, if so, is this a matter of realism, or accustomed subservience? These are tricky questions. As anthropologist Cesare Poppi has observed, the two approaches represented by the MoMA and Royal Academy shows on the one hand, and *Magiciens de la Terre* on the other, were equally problematic:

> On the one hand, an enduring 'traditional' art is relocated in an enduring 'other time and other space' – that of the 'primitive' – on

the other hand, works of art which are highly functionally specific and, in that respect, 'local' are relocated somewhere within the flux of the postmodern 'anything goes, the weirder the better'.

What results may be a bit of a mish-mash – Poppi cites the new African Gallery at the British Museum – that combines 'classic' and 'international modern' but misses all African art that fits neither. In the case of Chéri Samba's paintings, we might say that his artistic celebrity is due to the 'postmodern' hybridity of their references; that is, it's because they reference the West that they're noticed.

A similar openness to non-Western cultures, and to the creativity of their responses to the (often very different) experiences of 'modernity' – but which sought to acknowledge that this 'modernity' differed widely from place to place – characterized the ambitious exhibition *Century City* with which Tate Modern welcomed in the new millennium and inaugurated its vast new spaces in the former Bankside power station, in early 2001. A gesture of recognition that its own collection of 20th-century Western art was more indebted to the vitality of other cultures than had ever been acknowledged, *Century City* profiled the modern art, and avant-garde communities, that had emerged in nine major cities during the course of the last hundred years. Alongside the predictable choices of London, New York, Paris, Moscow, and Vienna were thus represented Bombay, Lagos, Tokyo, and Rio de Janeiro. Each city's display of art and its cultural context was selected by a curator from that city, invited to choose a decade of the last century on which to focus. The result was chaotic and uneven, but full of discoveries and surprises for anyone unfamiliar with such a global range of work – which included most visitors to the exhibition.

Century City succeeded in showing, at the same time, *both* the vital differences between what 'modernity' felt like in, say, Bombay and London, *and* the gravitational pull of Western capitalism, whose products and their marketing drew non-Western cities and their cultures into orbit around its headquarter metropolises. Thus

both the 'Bollywood' films of M. F. Husain, and the posters for them, which this octogenarian artist-laureate of India designed himself, drew on Western themes and styles but distanced them as they did so – his film *Gaya Gamini* of 2000, which featured in *Century City*, celebrates 'Indian womanhood' in a way that acknowledges the feminist revolution, but manages to avoid it at the same time. Thus also the 'Mono-Ha' (literally, 'School of Things') movement in late 1960s/early 1970s Japan – represented in the Tokyo section – whose self-consciously conceptualist engagement with natural materials and processes matched closely the interests of minimalists and post-minimalist artists in the USA and the '*arte povera*' movement in Italy during the same years. Sekine Nobuo's *Phase: Mother Earth* of 1968 (Figure 22), for example, a 2.7-metre-high circular tower of earth, taken from the identically shaped hole in the ground beside which it stands, seems to share much with the *Sites/Non-sites* of Robert Smithson or Michael Heizer's vast *Double Negative*, also of the late 1960s, in their common play around material and shape, monumentality

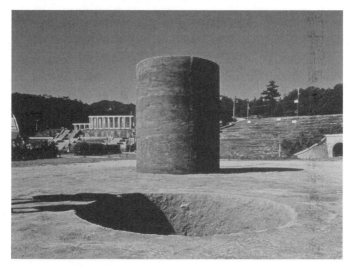

22. **Sekine Nobuo, *Phase: Mother Earth* (1968).**

and emptiness, ideas and things. Yet as Japanese art historian
Tatehata Akira has insisted, the relation between such closely
contemporary works is neither one of coincidence nor simple
influence. For while the Mono-Ha artists arrived at their aesthetic
position quite independently of Western art trends, they did so in
an art environment largely shaped by Western example and
institutions. This paradox reflects, of course, that of Japan itself in
the geopolitical arena.

Despite the presentation of such fertile and provocative
juxtapositions, *Century City* was criticized by some for inscribing
those very 'double standards' that bedevilled the earlier exhibitions.
Its presentations of the avant-garde cultures of Bombay in the
1990s and Lagos 1955–70 were made from a sociological
point of view, while those of the other cities were shown from an
art-historical one – thus, it was charged, framing Third World
cities such as these two as 'other' for a dominant Western
perspective. Of course, as with Chéri Samba, we might reply that
the fact of this domination can hardly simply be wished away, and
the often radical innovations of artists across the globe have tended,
ineluctably, to be assimilated to its model. If the Mono-Ha artists
of Tokyo were more or less ignored at the time by critics and
historians of modern art in New York, London, and Paris, the works
of Brazilian constructivists of the 1950s (such as Hélio Oiticica and
Lygia Clark) were disparaged as merely 'derivative' of European
or North American trends. The consequence, as Cuban critic
Gerardo Mosquera notes, has been the emergence of artistic
strategies that adapt, re-signify, and transform whatever
influences Latin American artists have acknowledged. But
Mosquera suggests that these strategies need to be complemented
by making the directions of cultural traffic more *complex* than they
are currently assumed to be – not only by reversing the dominant
'north-to-south', First-to-Third World direction of it, but by adding
more 'south-to-south' traffic as well. Whether this will happen,
however, remains to be seen; avoiding, let alone reversing, power
relations is easier wished for than accomplished, and the

institutions of modern and contemporary art across the world are well entrenched in them.

The price of creativity

With that almost complete institutionalization – and its corollary, the expansion of the field of art practice to the point where anything can count as art as long as it has been consecrated as such by art institutions – what remains as particular to the artist, as her or his unique attribute, is creativity. This is the residue of a century's steady commodification of art. One would think this, at least, to be irreducible; that if no longer by virtue of what he or she makes, or the materials he or she uses, or the practices he or she adopts, then an artist surely *is* an artist by virtue of the creativity of her or his imagination; and that this, equally surely, is beyond co-option or corruption. One would, of course, be wrong. Not only in that the creativity that is licensed as artistic is *awarded* that licence by a system of professionalization, whose gatekeepers are art schools (recognized artists who did not go to art school are rare indeed) and galleries, each of which are governed by strict, if tacit, protocols and criteria set – ultimately – by modern art's dominant institutions. It would be wrong also because creativity itself can be marketed, and has been; this, after all, is how the design professions emerged from the activities of the artistic avant-garde after the First World War, via strategic educational institutions such as the Bauhaus in 1920s Germany. While that avant-garde had its own spaces, traditions, and independence from the cultural mainstream – its own identity, and what might be seen as an *alternative* professionalism – it could withstand (to a degree) this co-option by commerce. But with the collapse of these that I noted in the last chapter, does any alternative to that co-option remain?

One area of recent new art-making, that of digital art, seems to suggest it does – both in its self-conscious reconnections with the ideals and the strategies of that early 20th-century avant-garde, and in its relative lack of dependence on the conventional institutions of

art. In the first respect: as media arts curator Christiane Paul observes, the example of Duchamp in particular stands behind much digital art practice. The exposing of the intellectual conventions of art which his 'ready-mades', such as the *Bottlerack* (Figure 4), achieved – their prioritizing of concept over object or craft skill – has lent itself to further exploration in the process-oriented medium of the computer. Also, the engagement with chance and randomness that, following Duchamp and his Dada associates, characterized the work of artists such as Rauschenberg and the Fluxus group, and composers such as John Cage (as I noted in Chapter 2), has been reprised in recent digital work. More generally, as Paul notes, the preoccupations of mid-20th-century modern artists have been updated or developed with the help of the new technology. Thus the photomontaged images of artists such as John Heartfield or the meticulously weird collaged engravings of Max Ernst have found echoes in more recent images, such as the computer-generated composite photographs of Nancy Burson, whose *Beauty Composites* of 1982 merged the faces of film stars Bette Davis, Audrey Hepburn, Grace Kelly, Sophia Loren, and Marilyn Monroe into a single eerie 'standard' of Western female beauty. And in Lillian Schwartz's *Mona/Leo* of 1987, whose alignment of the left side of the *Mona Lisa*'s face with the right side of Leonardo da Vinci's self-portrait drawing revealed an unexpected 'family' resemblance.

It is perhaps within one specific area of digital art-making, however, that of Internet art, that the inheritance of the modernist avant-garde is most consciously acknowledged. Given the ease of access to the Internet and the relatively low (for First World citizens) investments of capital and expertise required for intervention in its circuits of information, it is understandable that many artists who share the idealism and opposition to corporate capitalism that motivated the Dadaists, surrealists, and constructivists of the early 20th century should be turning to this medium. As art historian Julian Stallabrass writes,

The emergence of art on the Net hands back to artists a prize and an obligation long since surrendered in liberal societies in favour of artistic licence and cottage-industry production values: an explicit social role.

He also notes that

many of the actual conditions of avant-gardism are present in on-line art: its anti-art character, its continual probing of the borders of art, and of art's separation from the rest of life, its challenge to the art institutions.

Some Net artists explicitly invoke the heroic camaraderie of Picasso and Braque in their cubist days, seeing their own sharing and borrowing of ideas and tricks as the equivalent of those artists' shuttling between each other's studios in Montmartre. Others pool their efforts to more strategic ends, as in the case of several Net artists and groups who have worked on the issue of branding. Since brand names have become such powerful, and powerfully defended, properties, and since the Internet has become a primary means of their dissemination, the possibilities for effective intervention by small radical groups into the affairs of big businesses are considerable. MacDonald's, Shell, K-Mart, and Etoys are among firms that have suffered from the actions of such groups.

Yet, however inventively avant-gardist Net art has been, its reach, in cultural terms, has so far been limited. First, because there are still relatively few people in the world with access to a computer, and these are concentrated in the US, Europe, and Japan. Second, because economic interventions such as the above are, while of acknowledged nuisance value, either dangerously close to succumbing to the 'instrumentality' of the Net itself (its economic logic as a tool of big business and government), or too marginal and isolated to be of serious consequence for any but themselves – and, in either case, indistinguishable from other Net-based subversive activities such as 'hacking'. This is tantamount to saying

that the only way that artistic creativity can be kept from being 'instrumentalized' is by not being recognized as art. Such a strategy may well preserve the integrity of the contemporary, self-styled avant-gardist artist, but at the cost of severing the connection between contemporary art and modernism for all of its audience beyond the community of such artists.

Yet there is another, alternative ending. We can, after all, accept the (almost) inescapably commodified status of modern art. Art *as art* still has power to move, enchant, and enlighten us as viewers. And against the claims, and the current, of assertions that the vocabulary of contemporary art is that of our everyday experience, we can insist that, on the contrary, it is the *difference* from the everyday that makes much modern art so rewarding and enriching: the compelling obscurities of cubism, the (sometimes shocking) strangeness of surrealism, the sumptuous appeal of Matisse's paintings to the mind and the eye, the sublime simplicity of Rothko's veils of colour. This, according to the Marxist philosopher Herbert Marcuse, is how culture functions in modern capitalist society – by furnishing us with the profound aesthetic experiences that are lacking in capitalist social relations, by compensating for, and thus making good, that lack. And alongside these compensations for the banality of our everyday, there have been the more rebarbative tendencies: those of collage, montage, assemblage, whose provocative juxtapositions of materials and motifs have both prompted reflection on the socially constructed nature of reality, and nourished the representation of that reality in manifold ways, in film, popular music, and the commercial visual environment generally. Where, after all, would either Monty Python or modern advertising have been without the surrealists?

Which leaves us with a question, perhaps a dilemma. It's this: can we combine these alternatives – can we hold on *both* to that complex relationship with the history of modern art that gives contemporary art much of its meaning, *and* to contemporary art practices that are trying to avoid the 'museumization' of that

history? If we as viewers of modern art are to keep the faith of what motivated much of it in the first place, we are committed to an avant-gardist opposition to institutionalized modern art – that is, almost all of that art – which entails acquiescing in the abandonment of art *as* art, in favour of putting artistic creativity to the work of critiquing capitalist culture in other, more propitious, fields. But if we allow ourselves to enjoy the creations of modern artists in aesthetic terms, on the museums' terms, whatever visual gratification we derive from the encounter with their artworks, we gain it through a misapprehension of what they meant by them – it was, after all, the abstract expressionist painter Barnett Newman who said (in the mid-1950s) that 'if people really understood my painting it would mean the end of state capitalism and totalitarianism'. Do we, then, want art to console us for the shortcomings of capitalism, or to challenge it? Or both? It remains to be seen whether we can have our cake and eat it too.

Further reading

There are so many books on modern art, appealing to so many different interests and depths of pocket, that the following short set of suggestions for further reading on the subjects of each chapter is severely limited in its aims. My first aim is to give references for those authors and writings that I have specifically named in this book, to assist anyone who wishes to learn more about their ideas. The texts to which the reader is directed, in these cases, vary in their level of readability from the introductory to the scholarly, and you must take each as you find it – though they are all key contributions to our understanding of modern art and its history. My second aim is to suggest, for each chapter, a few accessible yet thought-provoking texts that stand out from the vast and general run of surveys of 20th-century art or aspects of it. Between them, these suggestions offer both a means to finding out more about what has interested you in particular, of the art and ideas I have discussed, and some starting points for following up the principal ideas around which the makers, critics, and historians of modern art have built their understanding of it.

Introduction: modern art – monument or mockery?

A useful overview of the early 20th-century avant-garde that synthesizes recent writings on this for the general reader is Paul Wood (ed.), *The Challenge of the Avant-Garde* (Yale University Press, 1999). Thomas Crow's *Modern Art in the Common Culture* (Yale University Press, 1995)

is a collection of sparkling essays by a leading radical art historian and critic. Carol Duncan's cited essay on early 20th-century vanguard artists is, like the others in her *Aesthetics of Power* (Cambridge University Press, 1993), full of sharp and profound challenges from a feminist perspective to conventional ideas about modern art.

Chapter 1: Tracking the avant-garde

T. J. Clark's book *The Painting of Modern Life* (Knopf, 1985) is a key text by one of the most influential of modern art historians. An assessment of how the complex and rapid changes in the urban fabric and daily life of late 19th-century Paris shaped the art of Manet and the impressionists, it is a challenging but utterly absorbing work. In another register, Peter Watson's *From Manet to Manhattan* (Hutchinson, 1992) is a very readable history of the modern art market that combines much information with enjoyable stories about its leading dealers and collectors. Dan Franck's *Bohemians: The Birth of Modern Art – Paris 1900–1930* (Weidenfeld and Nicolson, 2001) does the same for the colourful worlds of Montmartre and Montparnasse between Paris's *belle époque* and the Second World War. *Neo Avant-Garde and Culture Industry* (MIT Press, 1999), a collection of essays by art historian and cultural theorist Benjamin Buchloh, quoted in this chapter, casts a more searching and analytical eye on the postwar inheritors of the avant-garde legacy, while Chin-Tao Wu's *Privatising Culture* (Verso, 2002) is a mine of information on the corporate underpinnings of modern art's contemporary collection and exhibition. Jonathan Vickery's essay 'Art without Administration: Radical Art and Critique after the Neo-Avant-Garde', quoted here, is in *Third Text*, no. 61 (2002). The authors of *Occupational Hazard* (Black Dog, 1998), the collection of writing on recent British art cited in this chapter, are Duncan McCorquodale, Naomi Siderfin, and Julian Stallabrass.

Chapter 2: Modern media, modern messages

Charles Harrison's *Modernism* (Cambridge University Press, 1997) is a short and succinct introduction to the meanings and development of this concept in art, while Clement Greenberg's *Art and Culture* (Beacon Press, 1961) is a collection of enjoyably forthright essays by its leading

critical exponent, and a book that influenced a generation of art students. Michael Fried, *Art and Objecthood: Essays and Reviews* (University of Chicago Press, 1998) brings together key critical writings, including the title essay, by Greenberg's successor as formalism's chief theorist; an opposing approach to mid-century modernist painting is offered by T. J. Clark's essay 'Jackson Pollock's Abstraction', in Serge Guilbaut, (ed.), *Reconstructing Modernism* (MIT Press, 1990), and by Michael Leja's ambitious and compelling *Reframing Abstract Expressionism* (Yale University Press, 1993). Henry Geldzahler (ed.), *New York Painting and Sculpture 1940–70* (Pall Mall Press, 1971) contains a selection of keynote essays on its subject written within that period, including Harold Rosenberg's 'The American Action Painters' essay of 1952, while its many illustrations give a sumptuous visual overview. Leo Steinberg's *Other Criteria* (Oxford University Press, 1972) is a collection of searching and ground-breaking essays whose publication challenged conventional wisdom on modern art from Picasso to Rauschenberg. My own short book on *Cubism* (Tate Gallery Publishing, 1998) offers an introduction to this movement, and Picasso's contribution to it, in the context of the emerging avant-garde of pre-First World War Paris. Thierry de Duve's essay 'The Readymade and the Tube of Paint' (published in *Artforum* in May 1986) focuses on Duchamp's work of that pre-war moment, and discusses its significance for modern art, while James Meyer (ed.), *Minimalism: Themes and Movements* (Phaidon, 2000) provides a very accessible account of the Duchampian inheritance in this watershed movement of the late 1960s.

Chapter 3: From Picasso to pop idols: the eminence of the artist

Books on Picasso are legion, and new ones keep appearing all the time. Two very different recent works, each based on extensive research, are Natasha Staller, *A Sum of Destructions: Picasso's Cultures and the Creation of Cubism* (Yale University Press, 2001) and Elizabeth Cowling, *Picasso: Style and Meaning* (Phaidon, 2002). Books on feminism and art, too, are by now numerous; Christine Battersby's *Gender and Genius* (Women's Press, 1989) is a good starting point, as is Roszika Parker and Griselda Pollock's ground-breaking book *Old Mistresses: Women, Art and Ideology* (Routledge and Kegan Paul, 1981).

Their sequel, *Framing Feminism: Art and the Women's Movement 1970–85*, an indispensable anthology of writings, many of them otherwise unavailable, followed in 1987 (published by Pandora). Whitney Chadwick's *Women Artists and the Surrealist Movement* (Thames and Hudson, 1985), Hayden Herrera's *Frida: A Biography of Frida Kahlo* (Harper and Row, 1983), and Anne Wagner's *Three Artists (Three Women): Modernism and the Art of Hesse, Krasner and O'Keeffe* (University of California Press, 1996) are good, readable accounts of these specific artists, while Mandy Merck and Chris Townsend's *Art of Tracey Emin* (Thames and Hudson, 2002) is a selection of thoughtful, accessible essays (including that by Lehmann, cited) on a current art star. John A.Walker's *Art and Celebrity* (Pluto Press, 2003) usefully surveys the development of the relation between the two, while Peter Wollen's *Raiding the Icebox: Reflections on 20th-Century Culture* (Indiana University Press, 1993) offers fresh insights into many aspects of modern art, and is hugely informative too.

Chapter 4: Alchemical practices: modern art and consumerism
In 1990 the Museum of Modern Art in New York held a huge exhibition, *High and Low*, on the relations between modern art and popular/commercial culture, and the accompanying catalogue is an encyclopaedic survey volume, packed with information and illustrations – great fun to read but weighs a ton. In another vein, Terry Eagleton's cited comments are elaborated upon in his *The Illusions of Postmodernism* (Blackwell Publishers, 1997). Charles Jencks's definitions and support of postmodernism are presented in his little book *What Is Postmodernism?*, 4th edn. (Academy Editions?, 1996), while an alternative, critical postmodernism is outlined in the essays edited by Hal Foster in the text cited in this chapter, *Postmodern Culture* (Pluto Press, 1985). The best book on David Smith remains Rosalind Krauss, *Terminal Iron Works: The Sculpture of David Smith* (MIT Press, 1971), despite many more recent publications on his art. Although strangely titled, *After Modern Art: 1945–2000* by David Hopkins (Oxford University Press, 2000) is a lively and accessible survey, while Brandon Taylor's cited comments on 1980s art are in his *The Art of Today* (Weidenfeld and Nicolson, 1995). David McCarthy's *Pop Art*

(Tate Gallery Publishing, 2000) is a recent and fresh account of its subject; Guy Debord, *The Society of the Spectacle* (Buchet-Chastel, 1967) offers 221 pithy, often dense but equally often illuminating observations on modern capitalism and its culture; Peter Wollen gives a lucid and informative account of Debord's group, the Situationists, in *Raiding the Icebox* (see above for Chapter 3). Dick Hebdige's cited observations on postmodernism are from a challenging and important essay, 'Staking out the Posts', in his *Hiding in the Light: On Images and Things* (Routledge, 1988).

Chapter 5: Past the post: whatever next?

The catalogues of the exhibitions I discuss in this chapter are useful sources of ideas and information on their themes: in particular the New York Museum of Modern Art's *'Primitivism' and 20th-Century Art: Affinity of the Tribal and the Modern* (two volumes, 1984) and Tate Modern's *Century City*. Cesare Poppi's comments on these exhibitions are from his article 'African Art and Globalisation: On Whose Terms the Question?' in *Engage*, no. 13 (Summer 2003); Gerardo Mosquera's observations on the dominance of European and North American art are from his essay 'Good-Bye Identity, Welcome Difference', in *Third Text*, no. 56 (Autumn 2001). Christiane Paul's cited observations on contemporary digital art are in her useful survey of the subject, *Digital Art* (Thames and Hudson, 2003); those of Julian Stallabrass are in his richly informative and thoughtful *Internet Art: The Online Clash of Culture and Commerce* (Tate Gallery Publishing, 2003). The same author's critique of the 'yBa' ('young British artists') phenomenon, *High Art Lite: British Art in the Nineties* (Verso, 1999) is an incisive and entertaining broadside.

Index

*Numbers in italics refer to
illustrations.*

Index

Expand your collection of
VERY SHORT INTRODUCTIONS

Visit the
VERY SHORT INTRODUCTIONS
Web site

www.oup.co.uk/vsi

➤ **Information** about all published titles

➤ News of **forthcoming books**

➤ **Extracts** from the books, including titles not yet published

➤ **Reviews** and views

➤ **Links** to other **web sites** and main OUP web page

➤ Information about **VSIs in translation**

➤ **Contact** the editors

➤ **Order** other **VSIs** on-line

THEOLOGY
A Very Short Introduction
David F. Ford

This Very Short Introduction provides both believers and non-believers with a balanced survey of the central questions of contemporary theology. David Ford's interrogative approach draws the reader into considering the principles underlying religious belief, including the centrality of salvation to most major religions, the concept of God in ancient, modern, and post-modern contexts, the challenge posed to theology by prayer and worship, and the issue of sin and evil. He also probes the nature of experience, knowledge, and wisdom in theology, and discusses what is involved in interpreting theological texts today.

> 'David Ford tempts his readers into the huge resources of theology with an attractive mix of simple questions and profound reflection. With its vivid untechnical language it succeeds brilliantly in its task of introduction.'
> **Stephen Sykes, University of Durham**

> 'a fine book, imaginatively conceived and gracefully written. It carries the reader along with it, enlarging horizons while acknowledging problems and providing practical guidance along the way.'
> **Maurice Wiles, University of Oxford**

www.oup.co.uk/vsi/theology